LOOK UP EDINBURGH

LOOK UP EDINBURGH

World class architectural heritage
hidden in plain sight

ADRIAN SEARLE

FREIGHT
BOOKS

First published 2014

Freight Books
49–53 Virginia Street
Glasgow, G1 1TS
www.freightbooks.co.uk

A CIP catalogue reference for this book is available from the British Library

ISBN 978-1-908754-77-6

Typeset by Freight in Adobe Caslon Pro and Tungsten
Printed and bound by PB Print UK in the Czech Republic

the publisher acknowledges investment from
Creative Scotland toward the publication of this book

CONTENTS

FOREWORD

I've lived in Glasgow for almost 18 years but don't hold that against me. I spent my formative years in Edinburgh in what must be one of the most beautiful cities in the world.

In October 2013 I published the book *Look Up Glasgow*, inspired by the outstanding, world-class architectural sculpture and decoration to be found 'hidden in plain sight' at the tops of buildings throughout the Second City of the Empire. The book was a great success and, with a real passion for architectural heritage forged while studying History and History of Art at the University of Edinburgh in the second half of the 1980s, I turned to Scotland's capital city for further inspiration.

Initially I was worried that I wouldn't find enough to fill a whole book. For me, Edinburgh's appeal is the contrast of the sublime, reductive uniformity of the Georgian New Town with the austere but rather anarchic Scots Baronial of the Old Town. Although I lived in Edinburgh for the best part of 8 years, I didn't remember seeing much sculpture on the capital's buildings. When, at the outset of this book, I looked closer I realised how unobservant I'd been.

Man has been making figurative sculpture for tens of thousands of years, ever since he learned to hold a stone axe. What it is that makes us want to capture and reimagine the world around us through art is something that has challenged art historians and philosophers for almost as long. But it's my strong belief that architectural decoration, whatever form it takes, is a vital part of our relationship with our environment.

Buildings are not just walls and a roof. Architecture is a conversation between a structure, its surroundings and the people who exist within it – as Grand Designs' Kevin McCloud loves to say. And to my mind, sculpture and decoration help extend that conversation. They help people understand what a building means, help them respond to it in their own unique and individual way. Most importantly, they help us form a relationship with our environment.

This book is very much a personal selection and it not intended to be exhaustive. I daresay I could have travelled further and included more had time allowed. If I have missed out a favourite piece of sculpture of yours, I humbly apologise.

My principal interest is in decoration on the sides of secular buildings. Generally I try and avoid ecclesiastical architecture as this is a specialist subject in its own right. However, in Edinburgh, a city of a hundred spires, it was impossible to exclude churches completely. Again, I've made a personal selection, within a very small geographic area, of certain iconic buildings I feel merit inclusion.

I make no apology for using the images here to inspire some of Scotland's best writing talent. It's a pleasure and a privilege to have been able to commission Jane Bonnyman, Ron Butlin, a former Edinburgh Makar, Anna Crowe, Theresa Muñoz and Dilys Rose to write verse on the subject of Edinburgh's wealth of architectural decoration. These poems provide moments of reflection on the artworks themselves while connecting the past to the present day.

I love contemporary architecture. As a passionate collector of Danish mid-century furniture, I draw huge pleasure from the purity of style championed in the 1960s and 70s by companies like Glasgow's Gillespie, Kidd and Coia. I don't agree with Prince Charles's assertion that most modern architecture is a "monstrous carbuncle". However, I also love the crazy ebullience of older buildings that have the confidence to use sculpture and ornament to entertain and educate those of us passing by on a daily basis. That many of these fabulous works of art have become damaged or corroded by pollution amounts to cultural vandalism.

But, for me, the real tragedy is that so many of us have become immune to the delights around and above us. We're so focused on where we need to be next, or what we're about to buy, that we forget to stop, look up and enjoy the fabulous wealth of stunning architectural heritage that surrounds us.

So the next time you're in the centre of this great city, whether as inhabitant or visitor, remember the cry: Look Up, Edinburgh!

— Adrian Searle

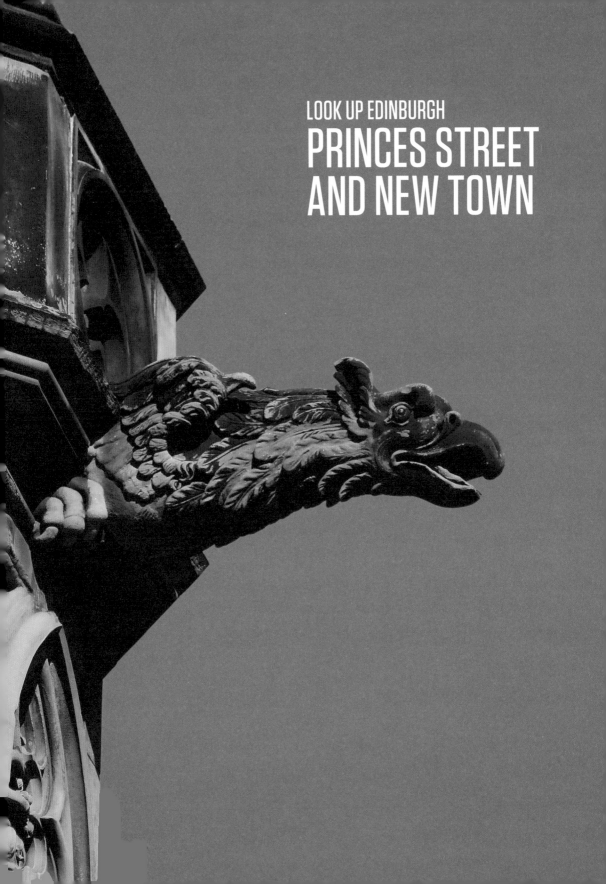

LOOK UP EDINBURGH

PRINCES STREET AND NEW TOWN

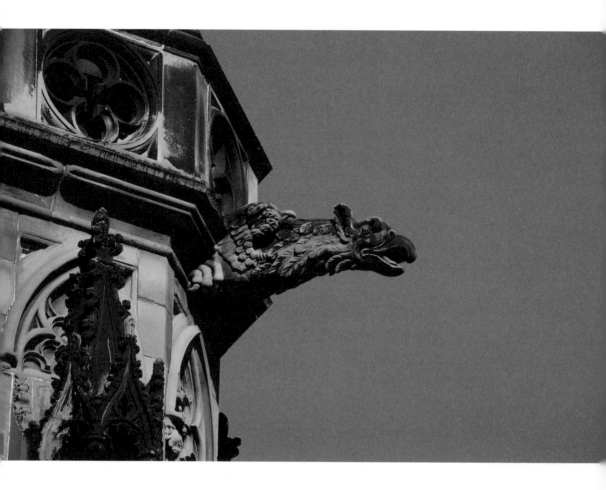

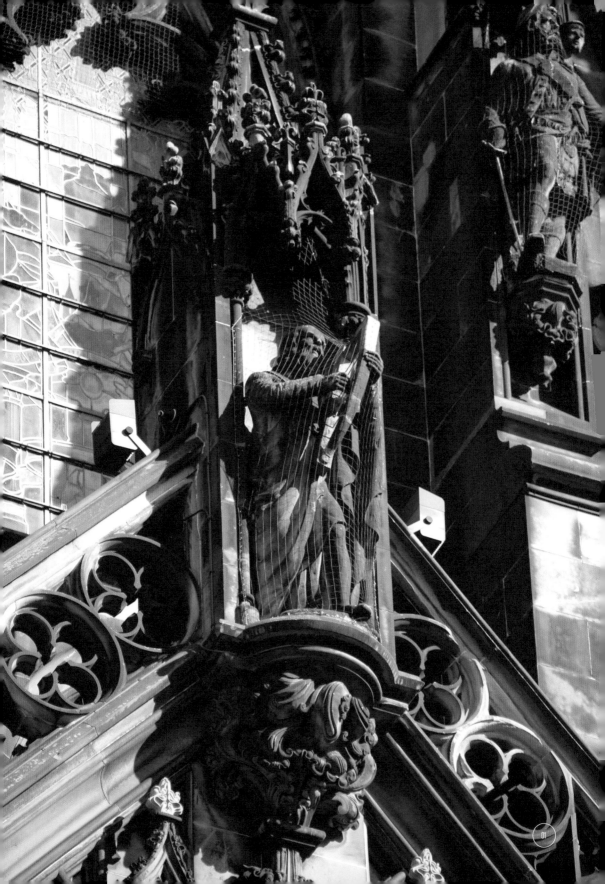

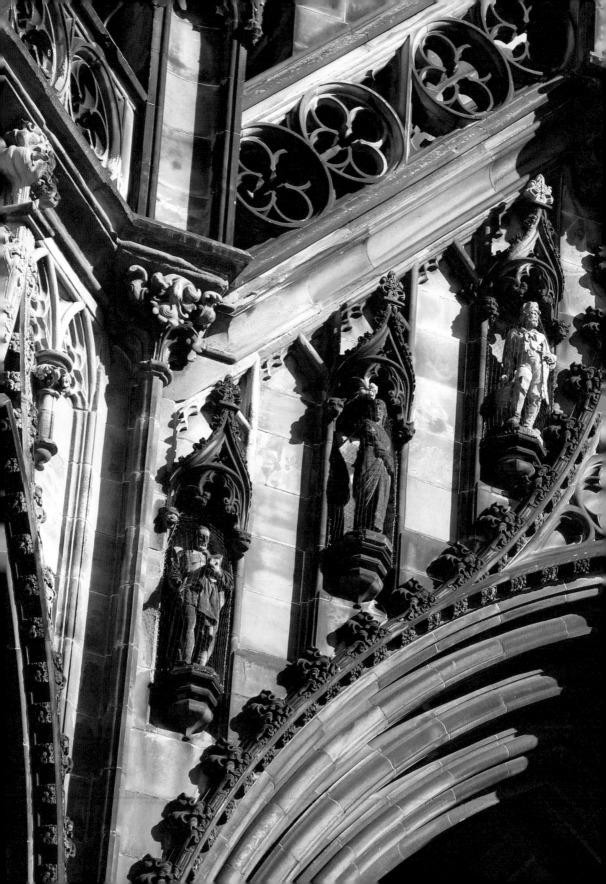

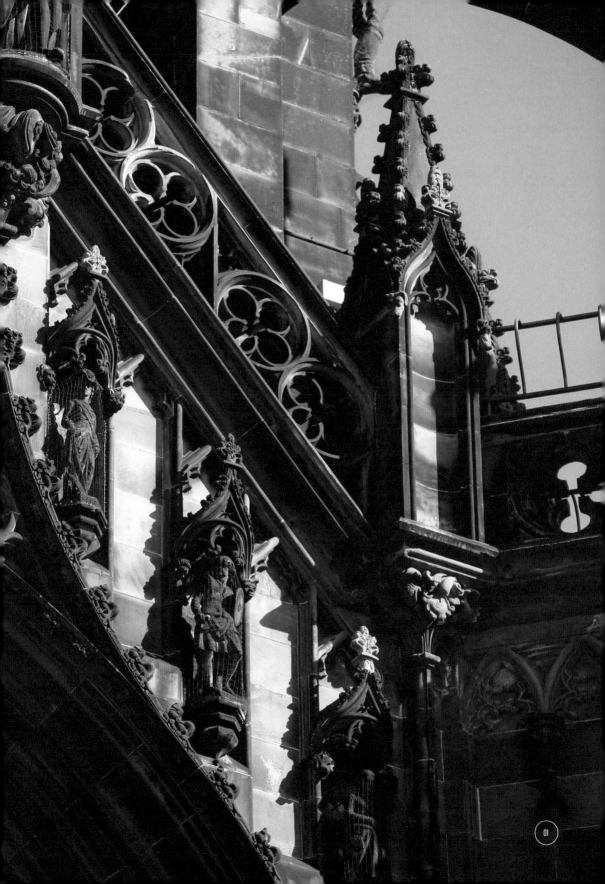

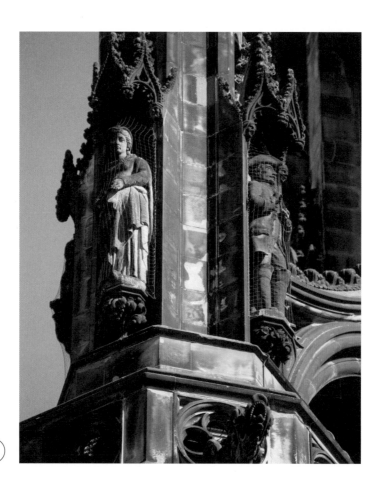

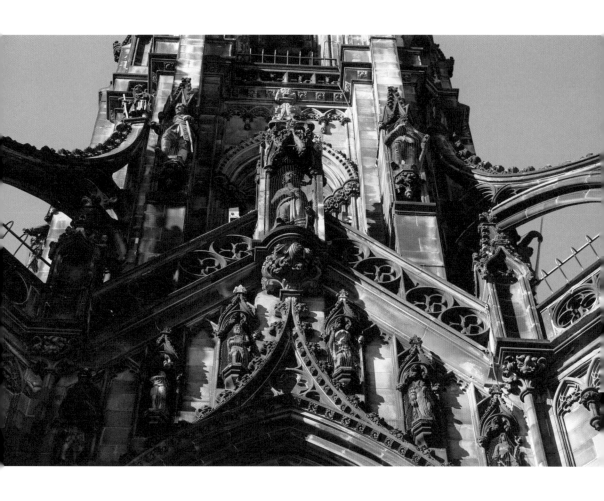

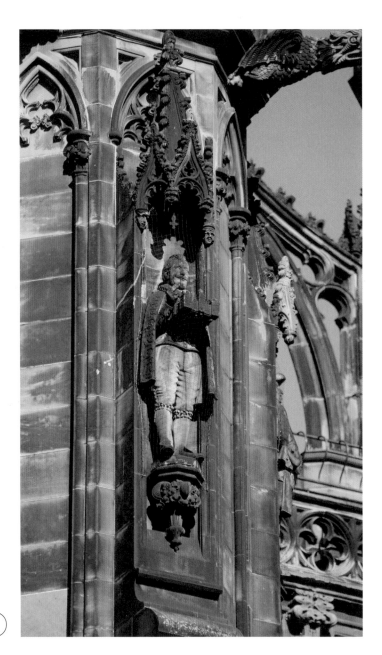

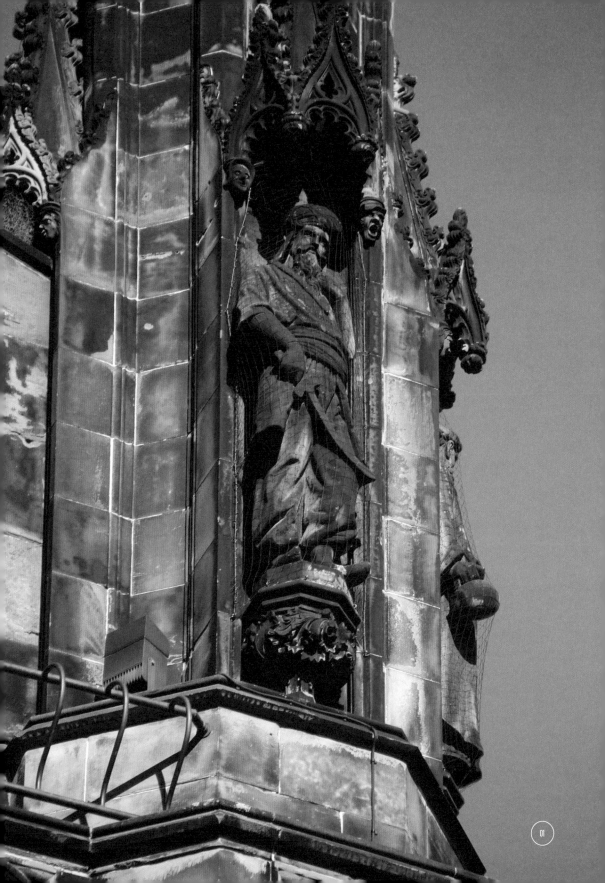

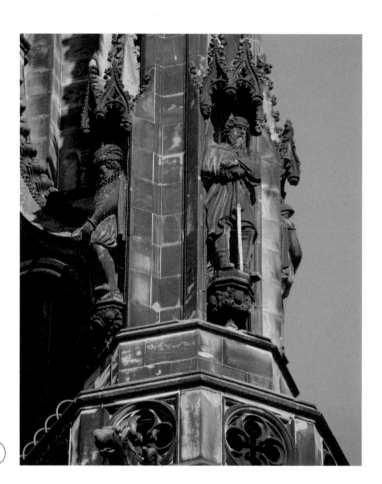

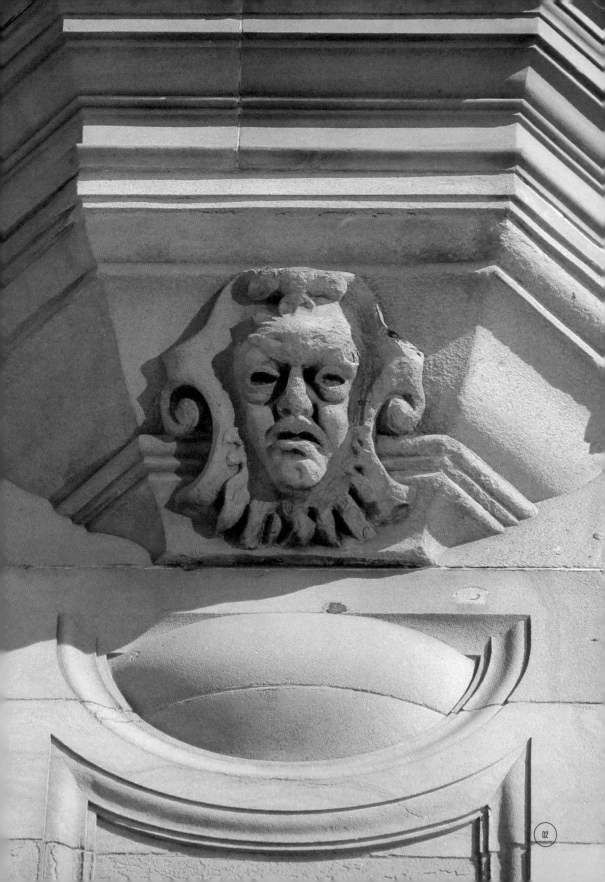

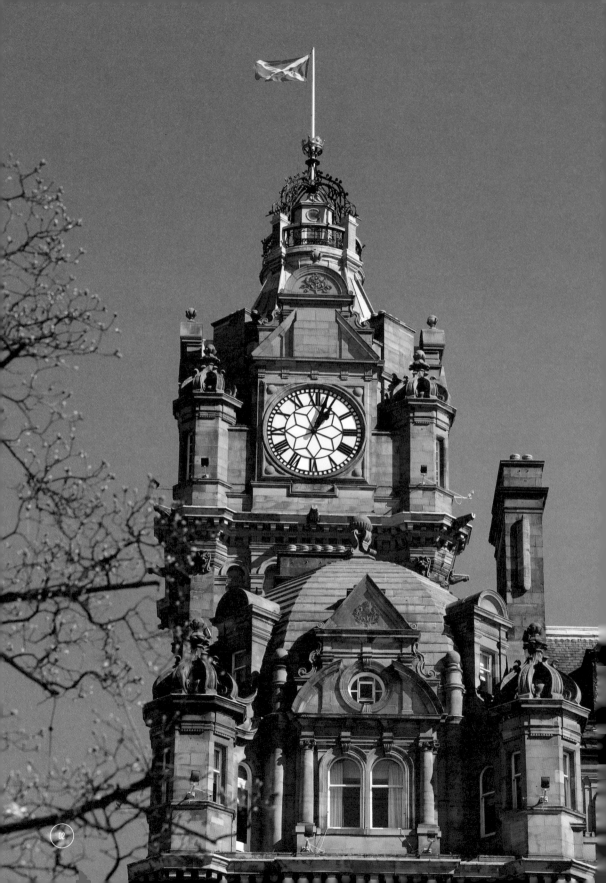

Our Plea To The Balmoral Clock

(whose hands are always set three minutes ahead)

Ron Butlin

Gazing down upon our all-too-human delay
of unfinished city streets and roofs,
upon a mortality that clearly
cannot be relied on,

You seem to promise us – what?

Do you feel the urgency behind our as-yet
unspoken words of love, the ache within
the gestures we lack the courage
to complete? Do you understand our need for hopes
and fears to free us from the present?

If so, what we ask of you is this:
let whatever time you choose to show
be intended as an invitation,
and a blessing on us all.

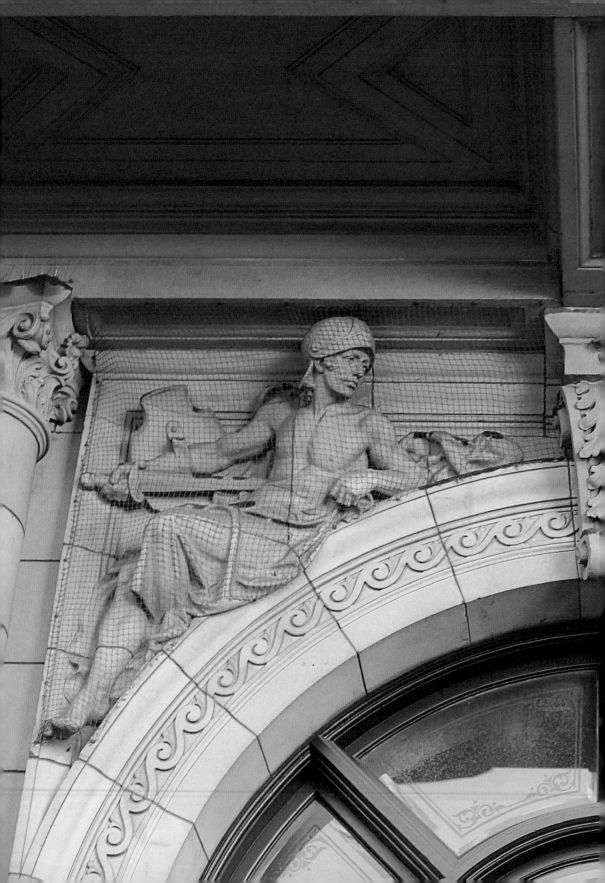

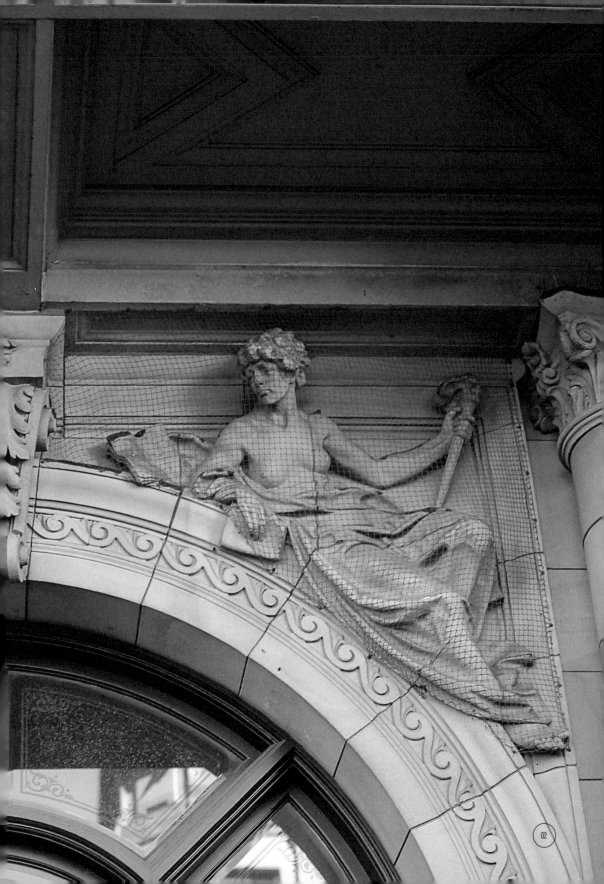

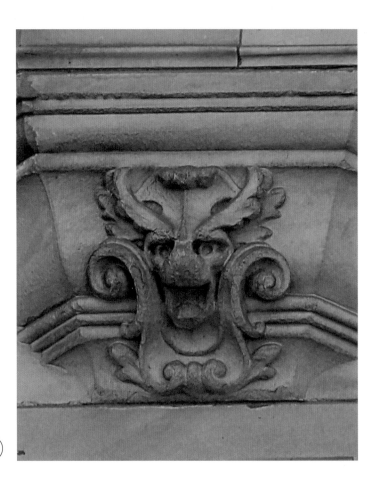

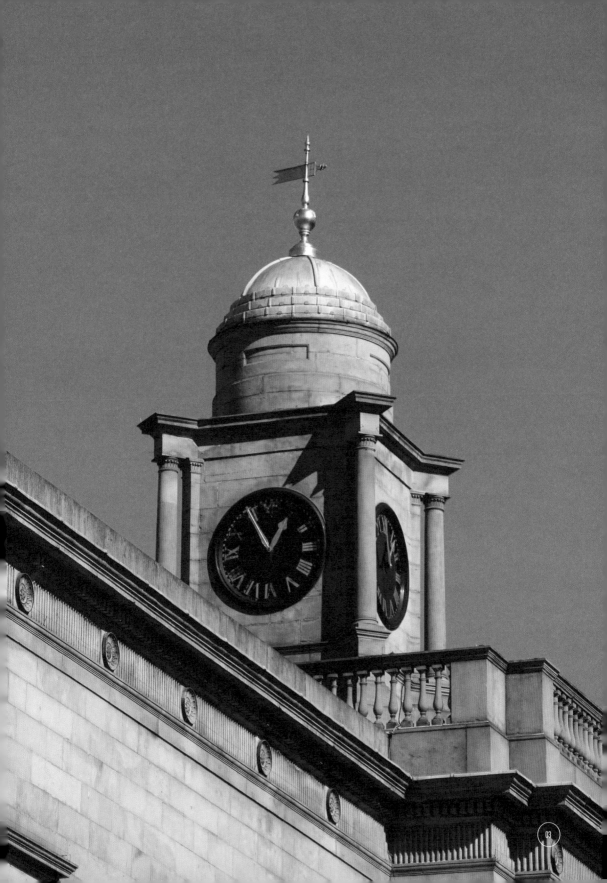

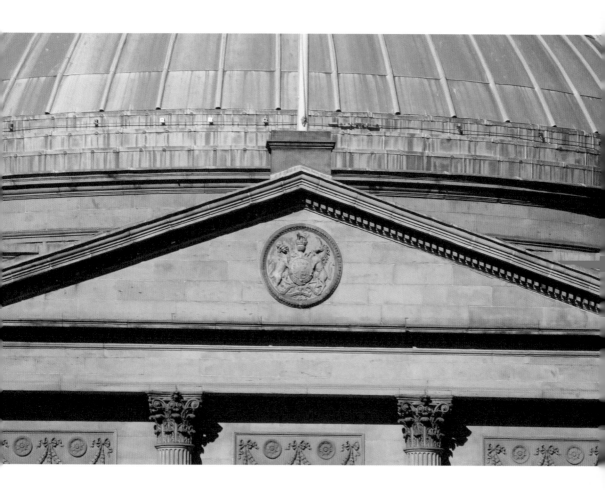

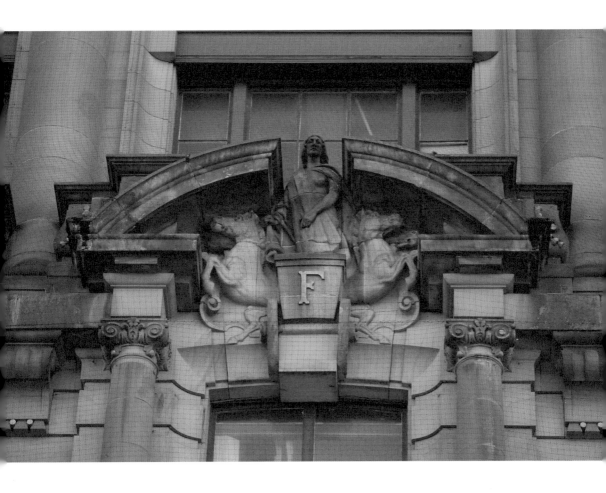

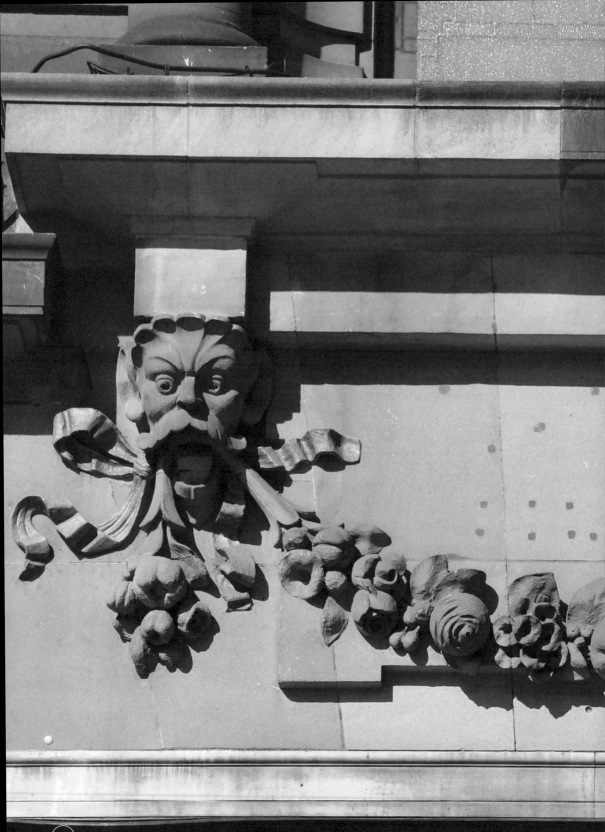

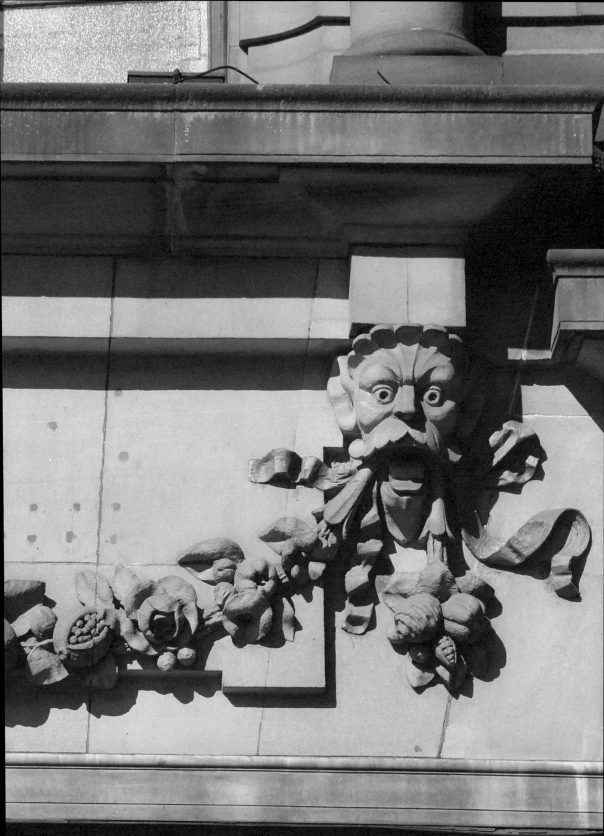

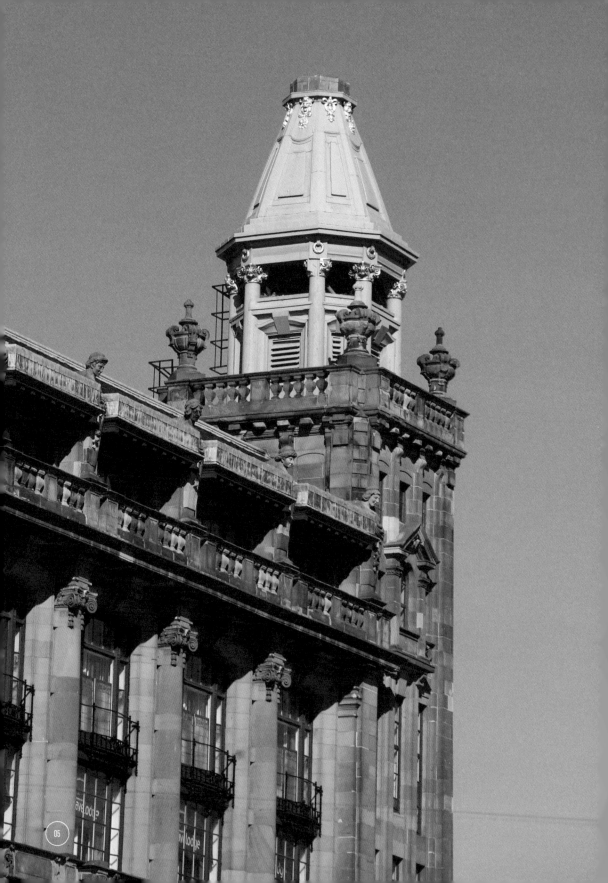

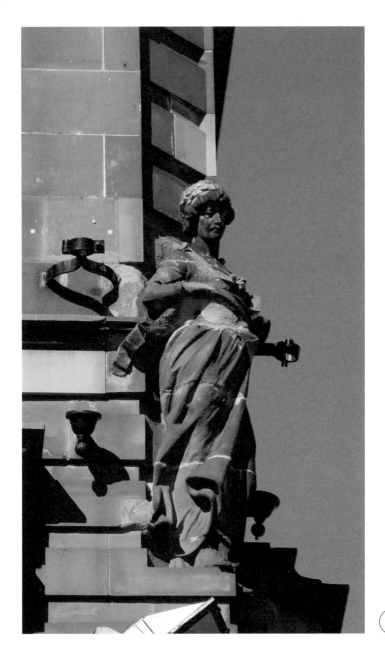

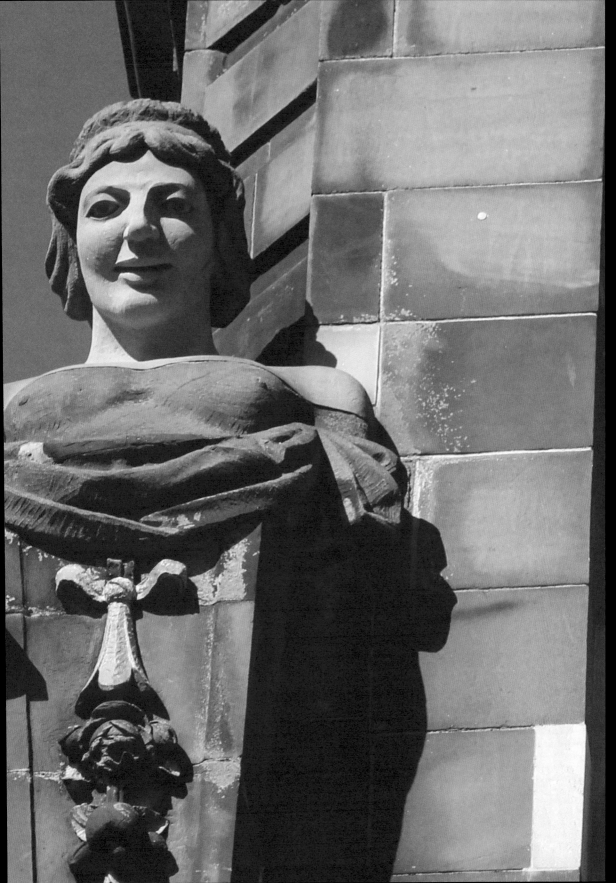

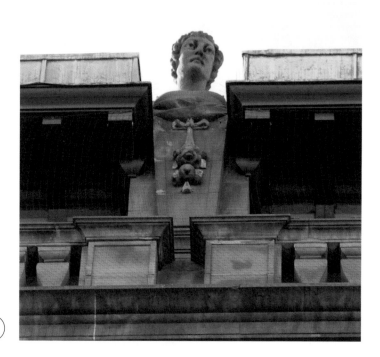

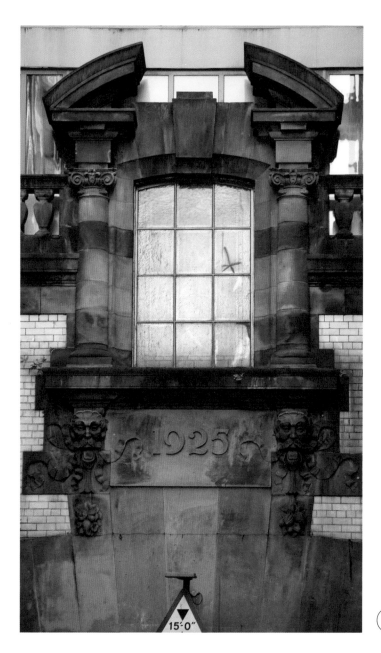

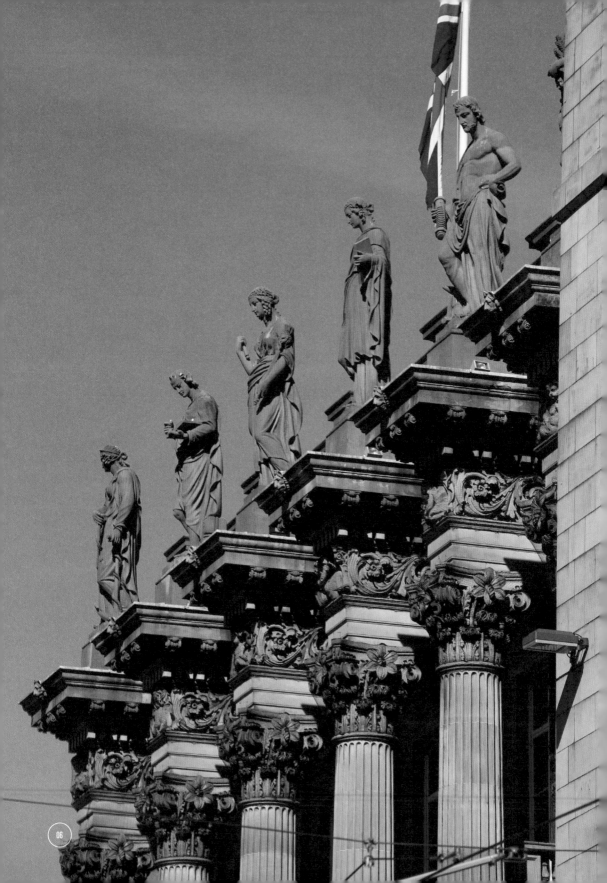

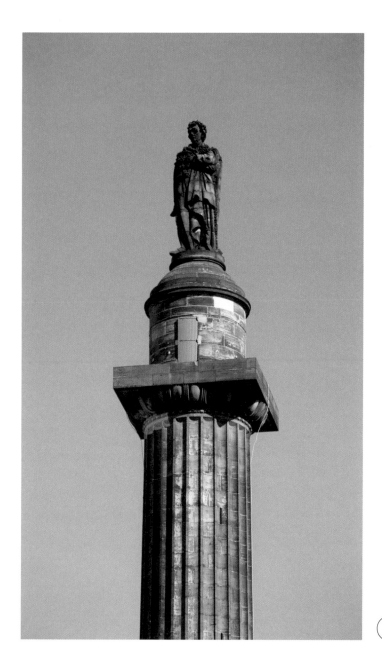

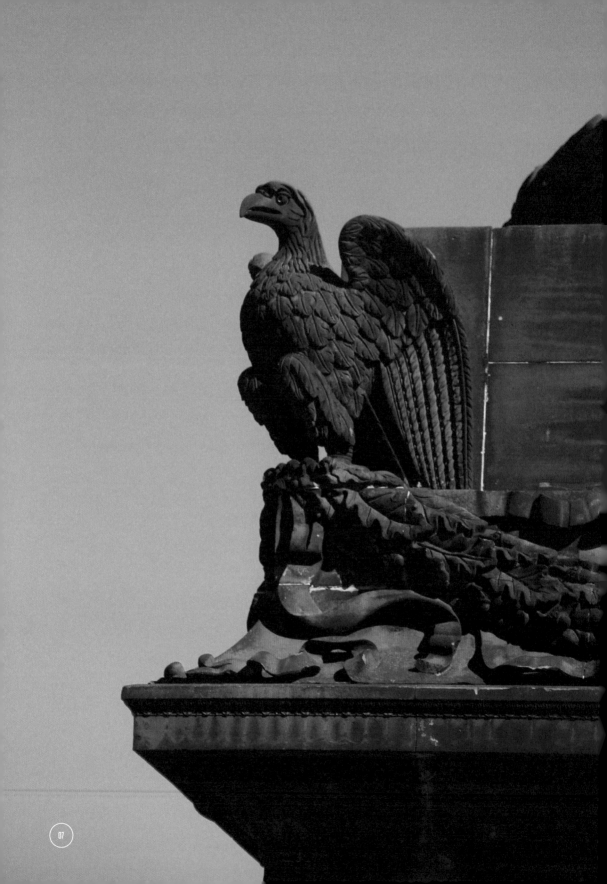

Tony Blair's Butterfly Effect

Ron Butlin

Having glided smoothly upwards –

Up...!
And up ..!
And up ..!

Behold, Tony Blair standing where he should be –
poised sixty years and more above
the city of his birth.

Time enough for down-soft feathers to have
interlocked
and stiffened into archangel-strength wings,
to curve himself a profile of absolute conviction,
take on a gaze of stone-hard sincerity.

Set so high above the rest of us, he hears
God whisper His divine intentions.

Any moment now he might feel the need to stretch.

Tony Blair's butterfly effect – when these wings beat,
distant city walls tumble,
men, women and children die.

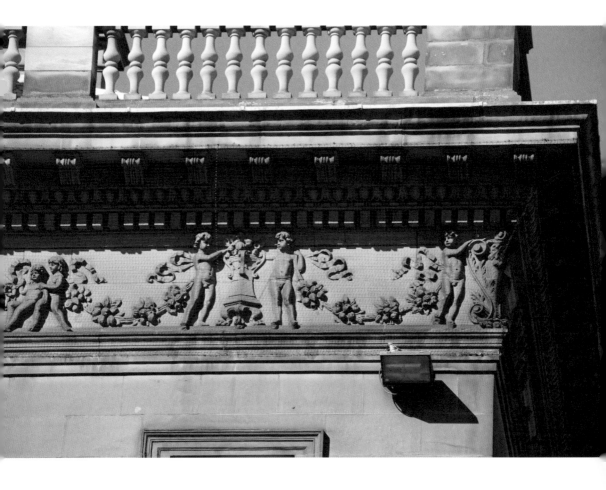

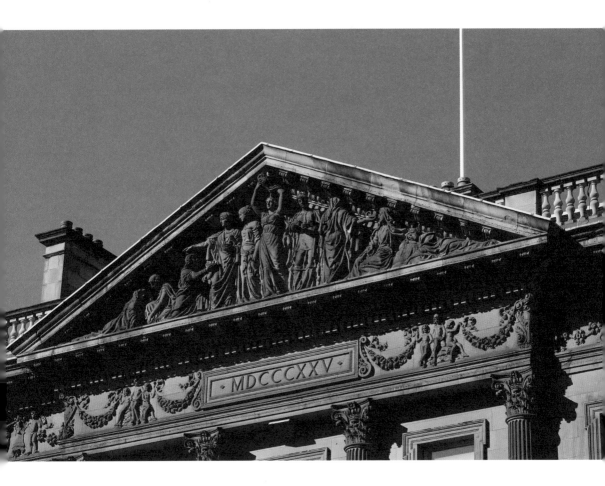

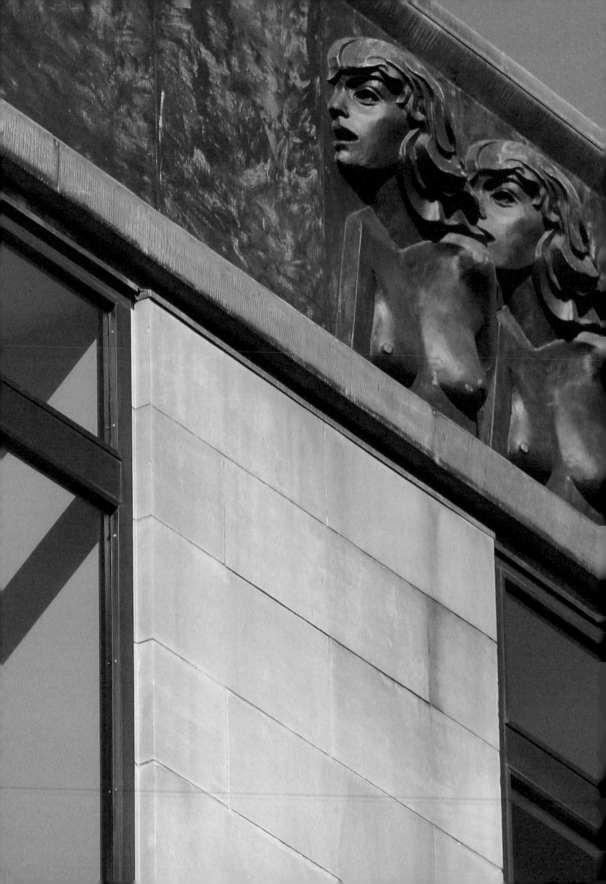

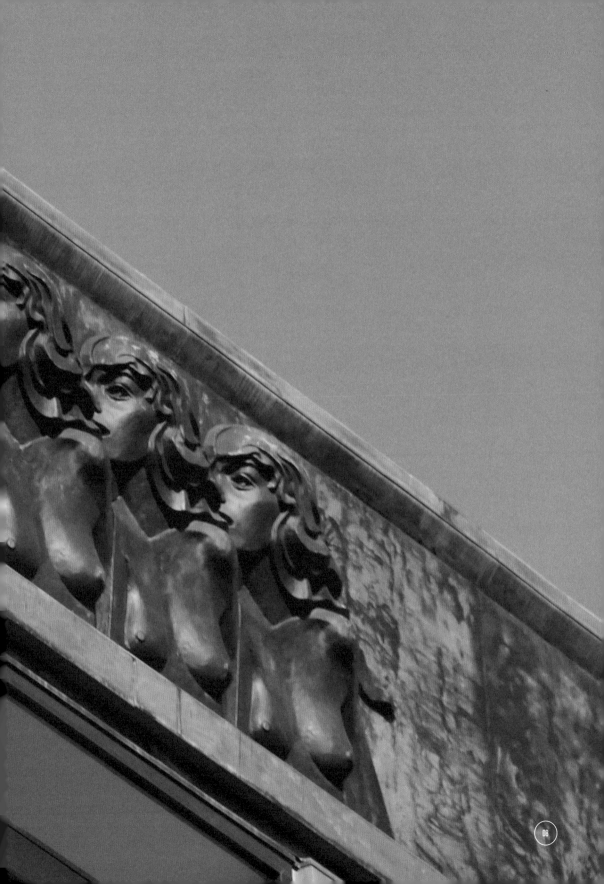

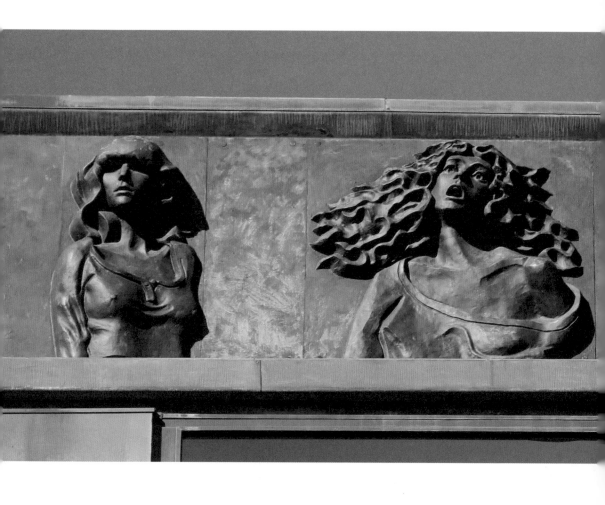

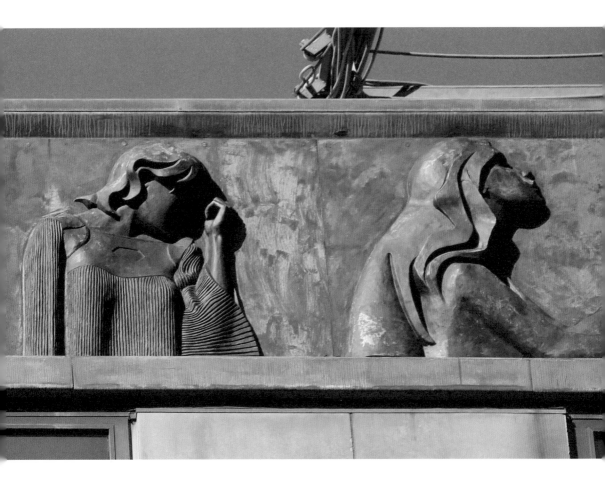

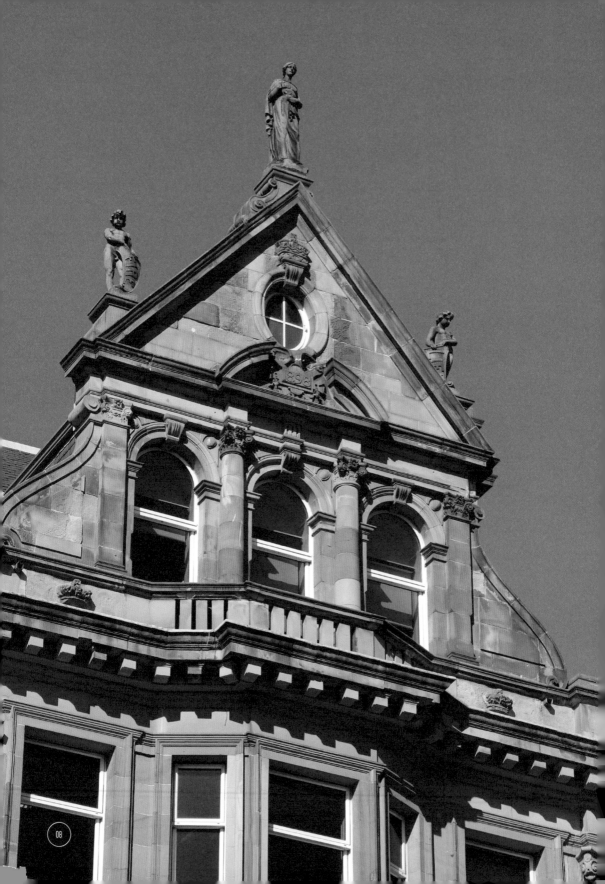

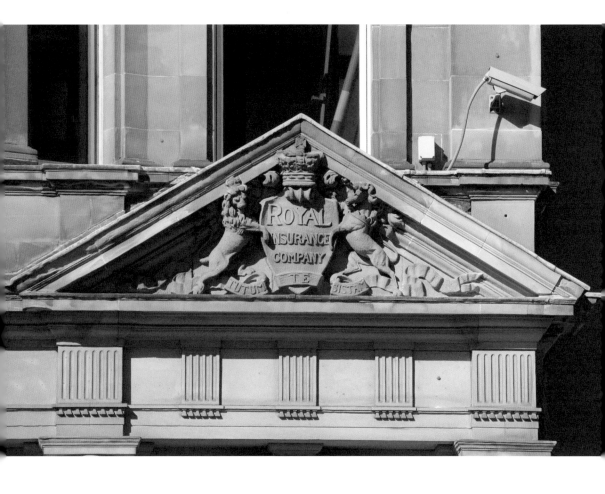

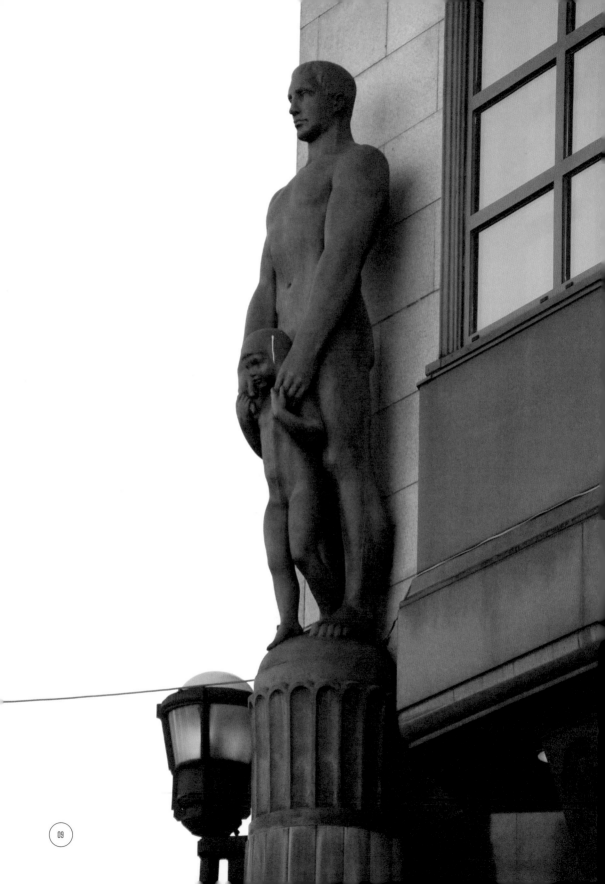

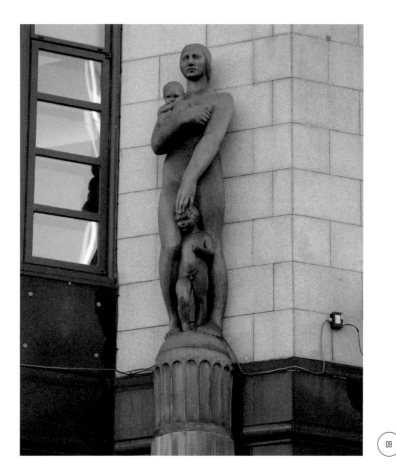

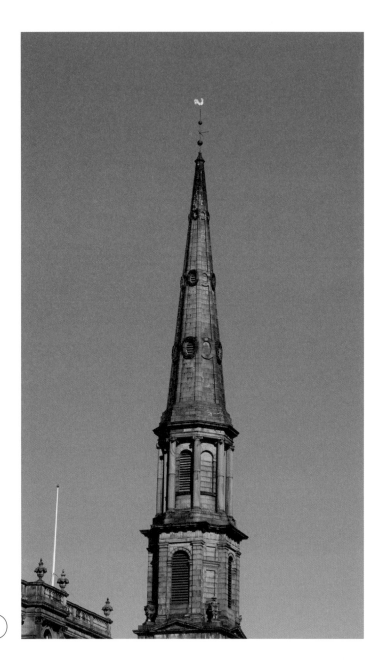

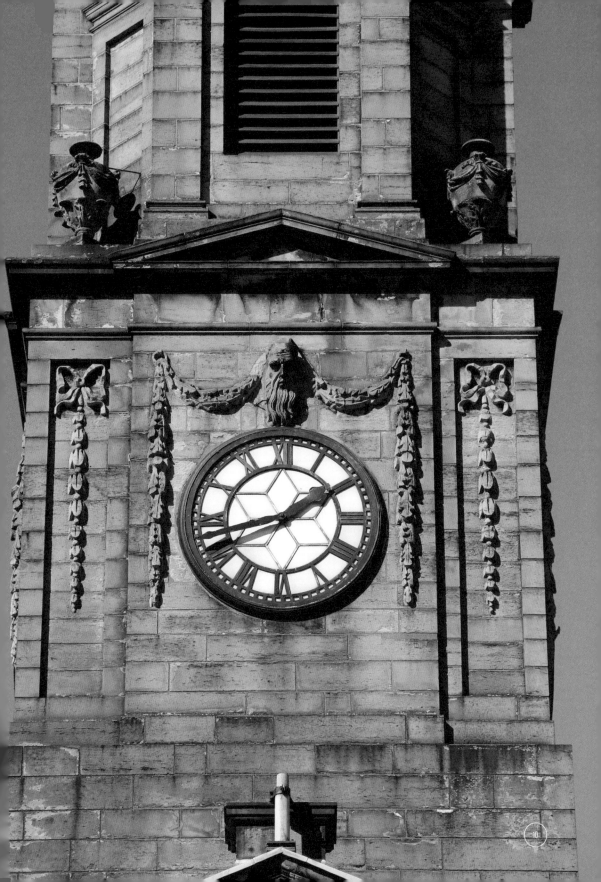

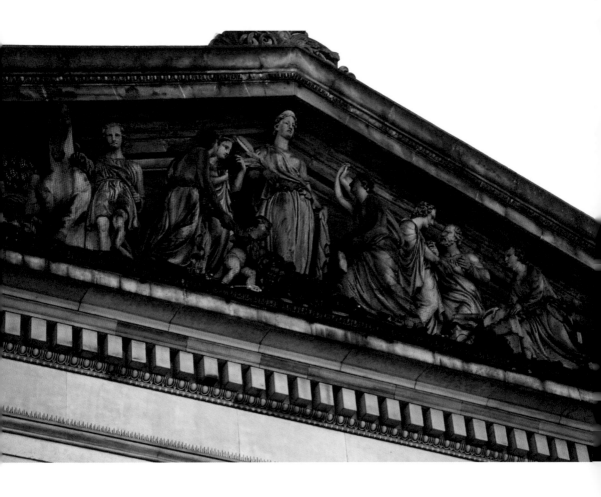

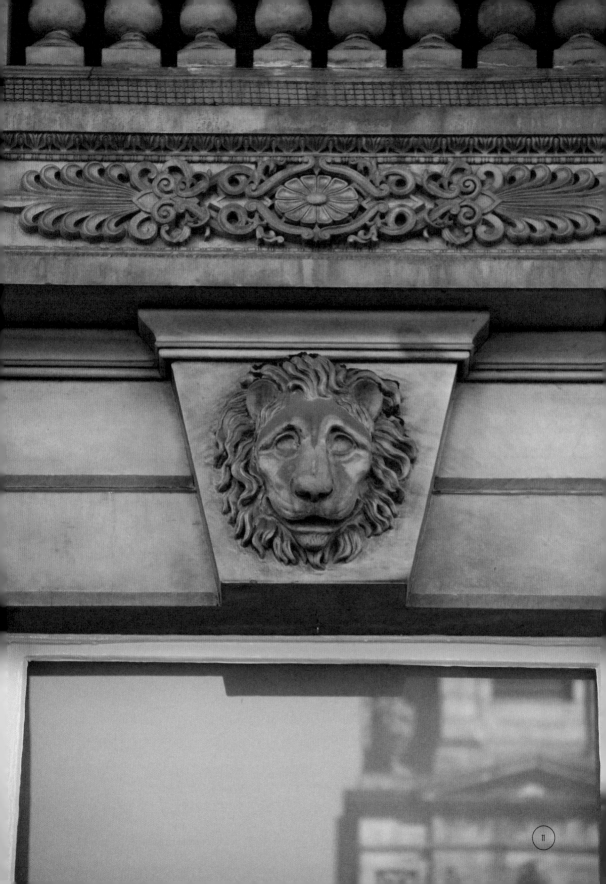

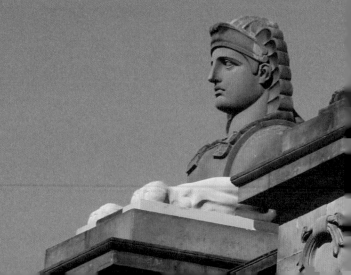

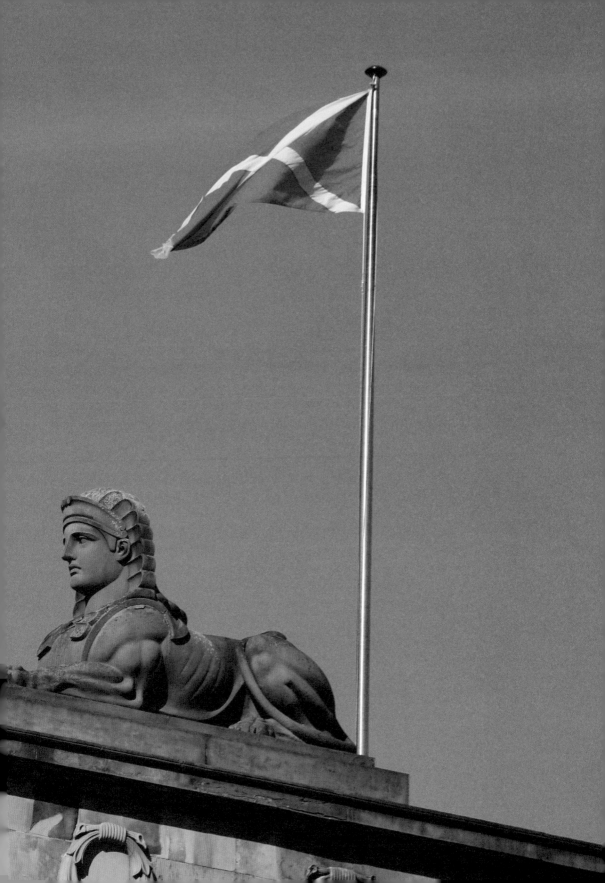

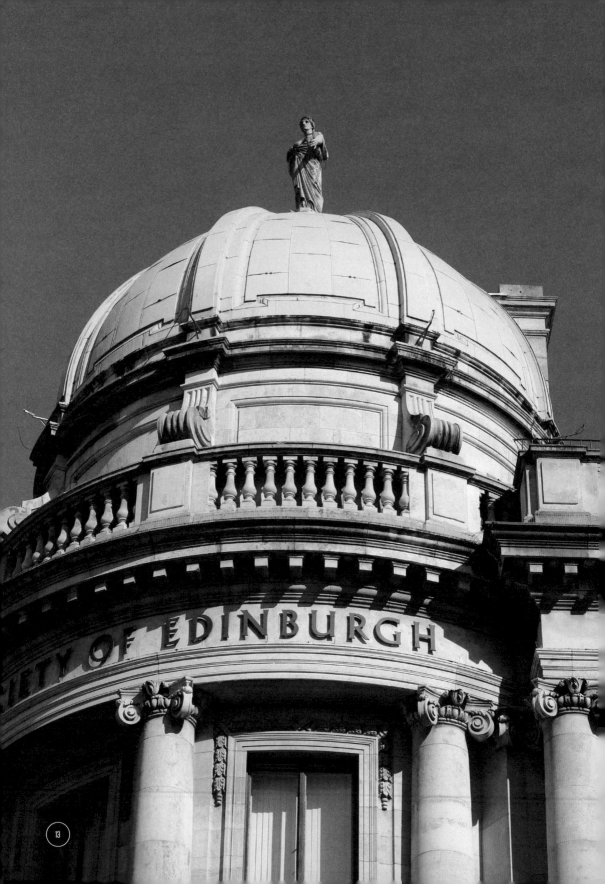

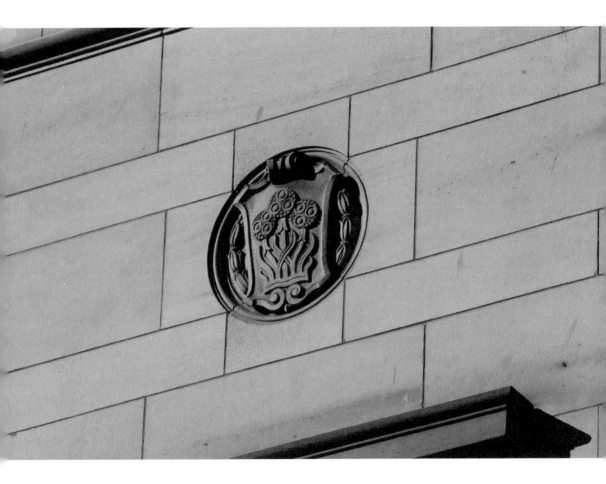

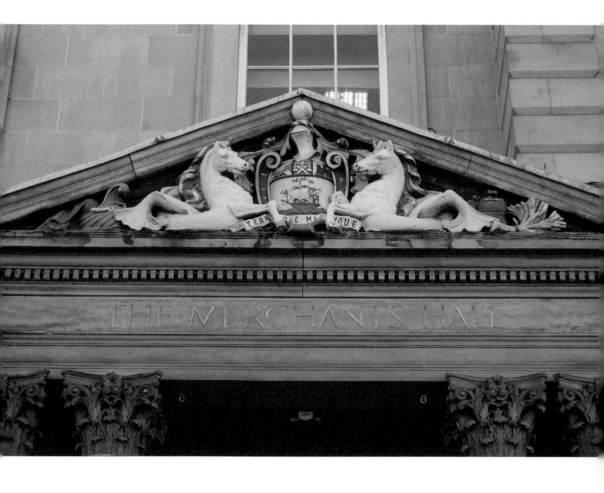

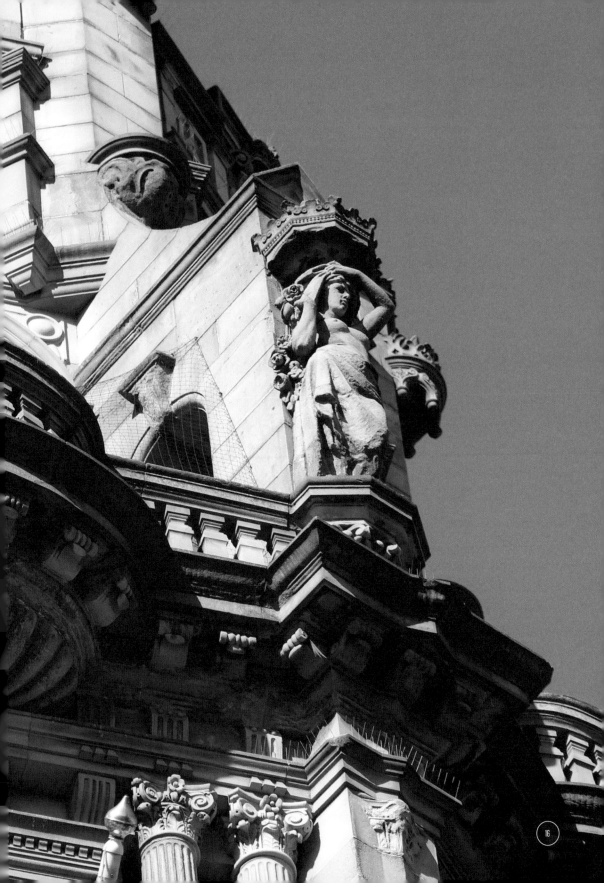

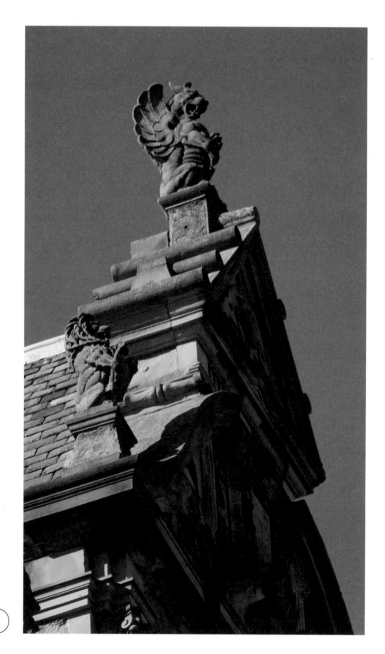

16

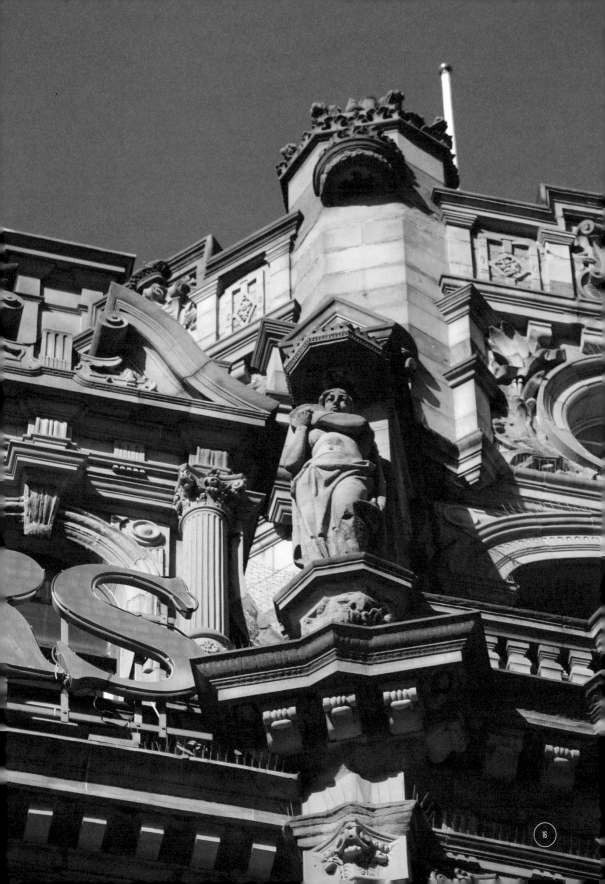

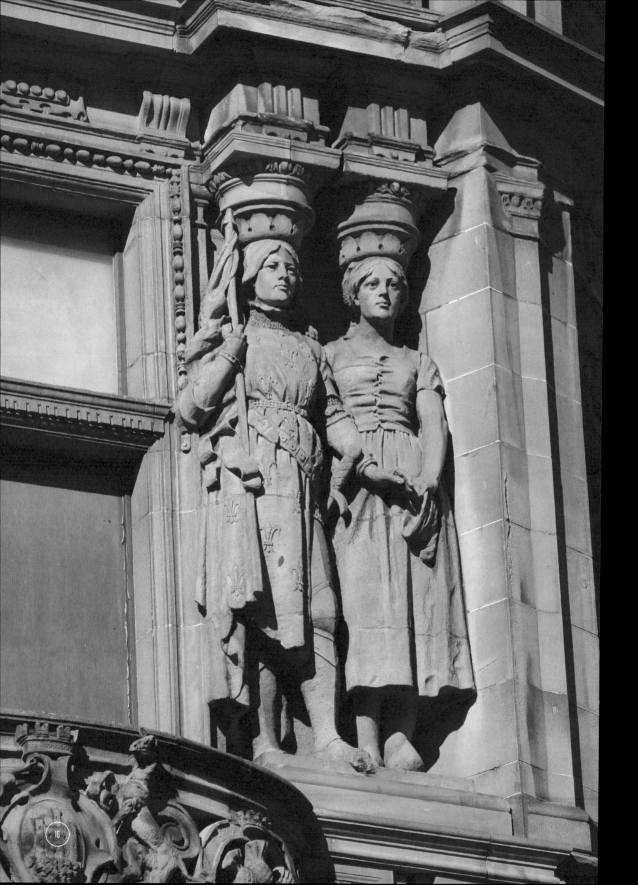

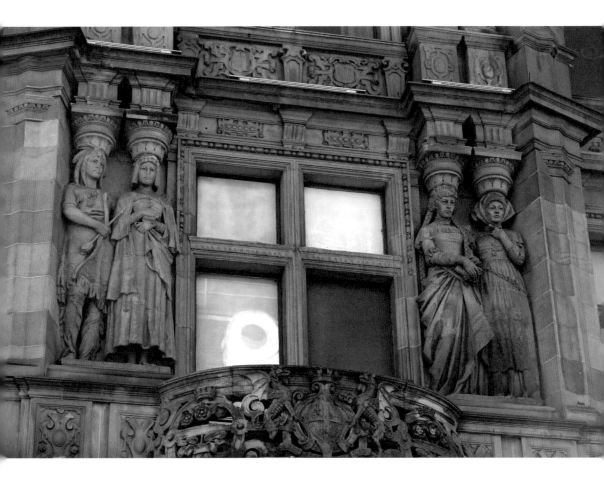

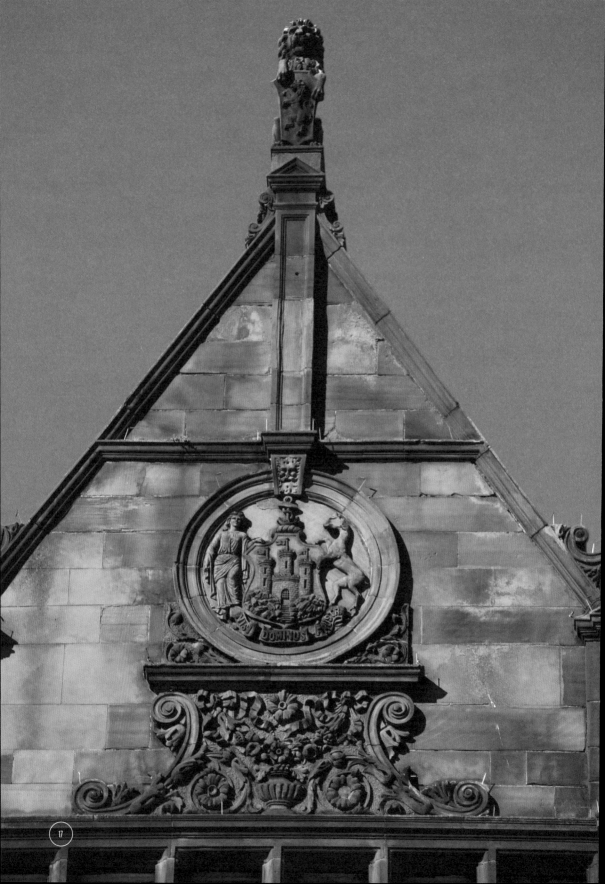

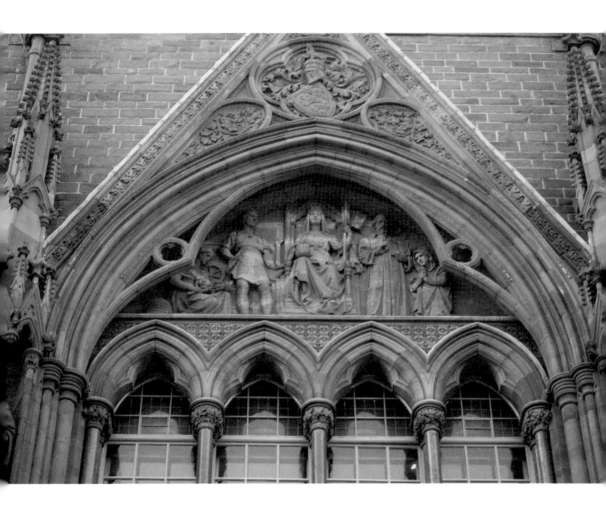

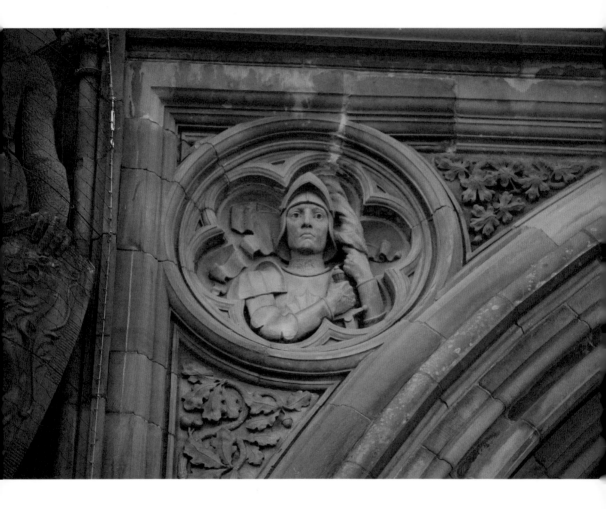

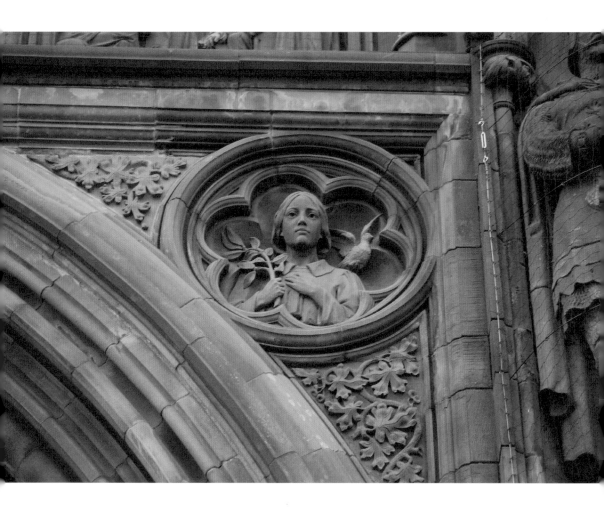

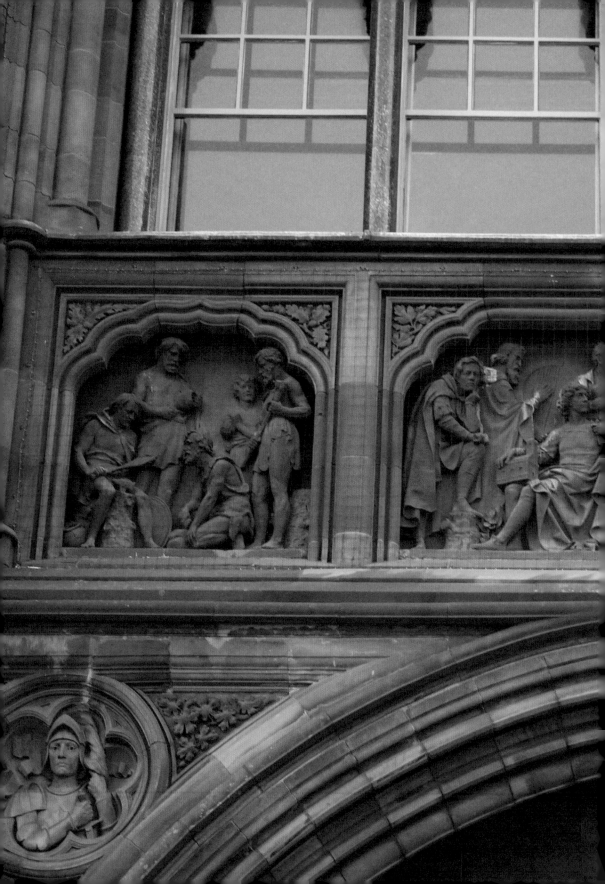

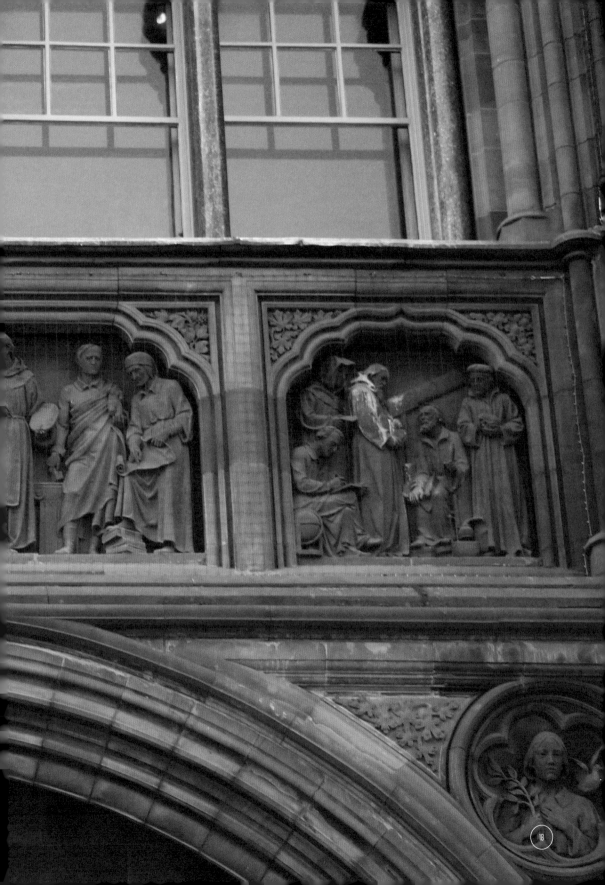

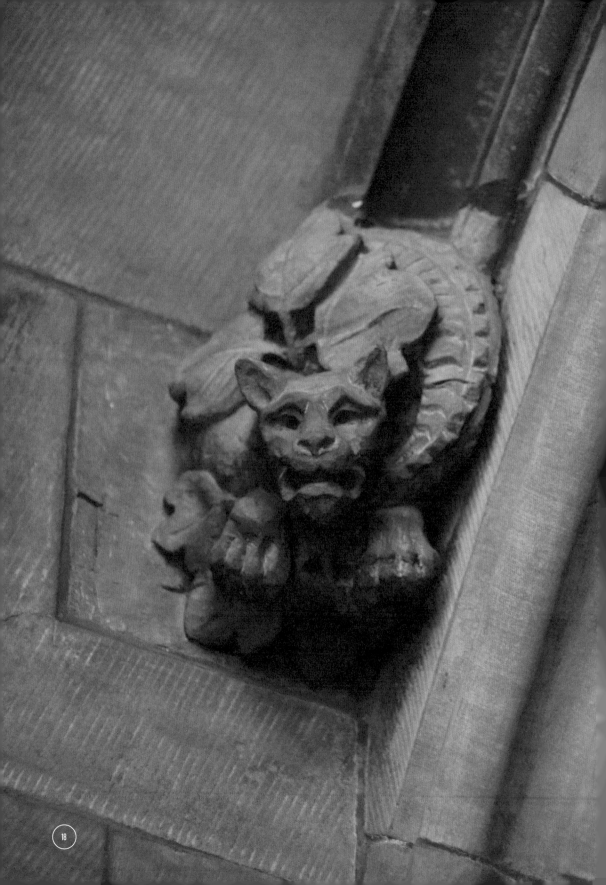

National Portrait Gargoyles

Theresa Muñoz

Pity those gargoyles
guarding the gallery,
nobody sees your raised wings
your pert squashed noses
and curious eyes, nobody tries
to sneak a non-flash photo
or a thumbs-up selfie with you,
does it hurt your small pride
when those tourists amble past
your crouched pose and stone feet
to view the real art:
oils of smug kings, fat ladies
and the tub-white busts of dead men,
who couldn't appreciate your monster grin
and pointy chins, who else sees
you gargoyles are the first,
the first art we see face-to-face.

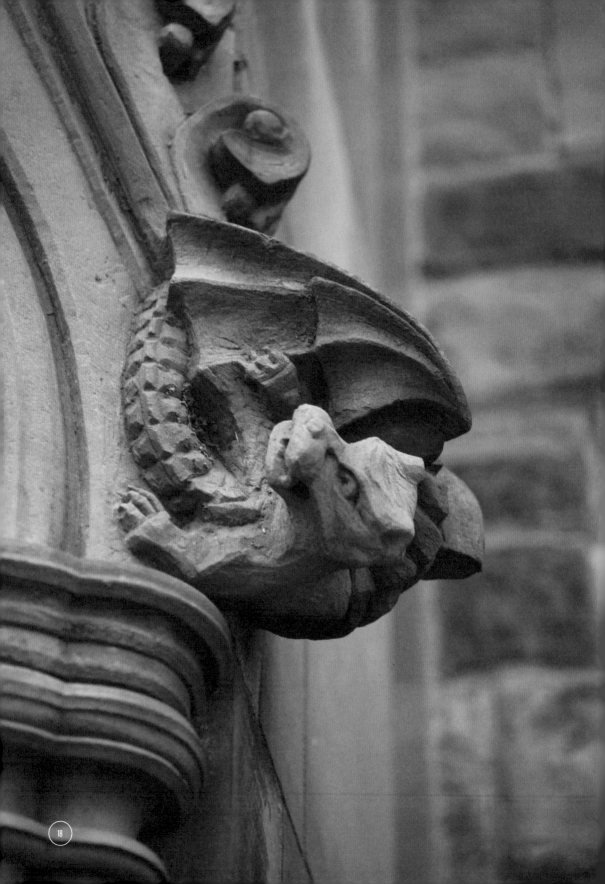

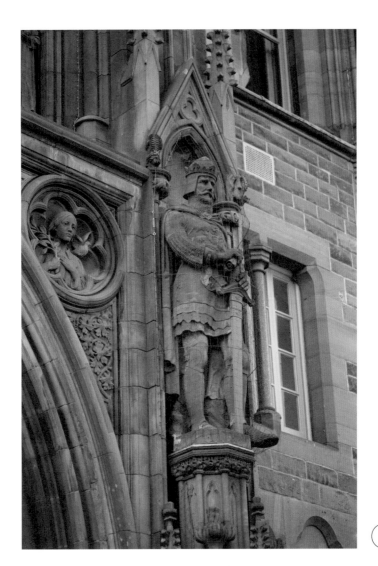

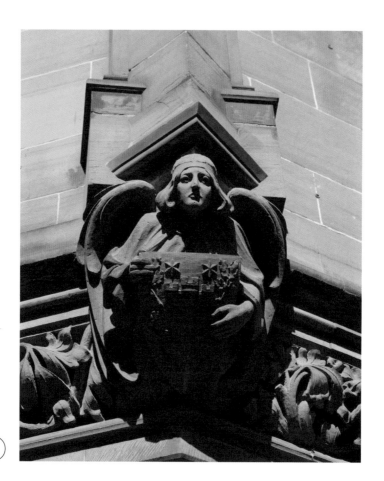

18

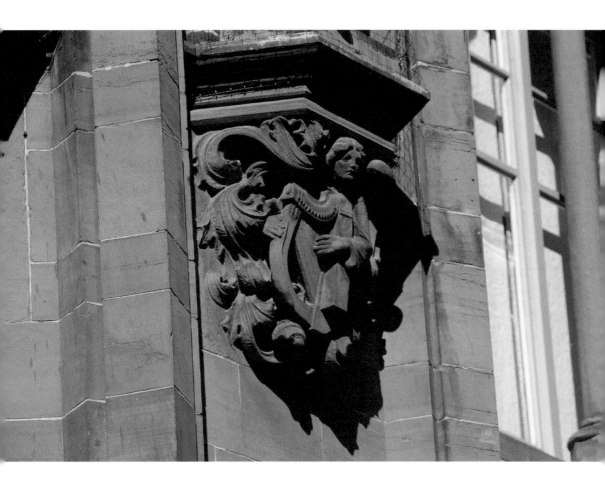

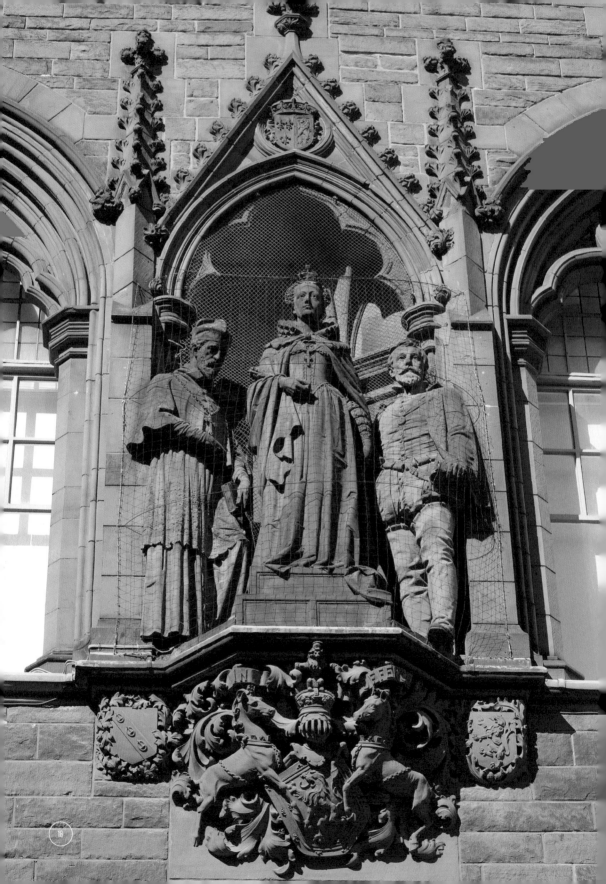

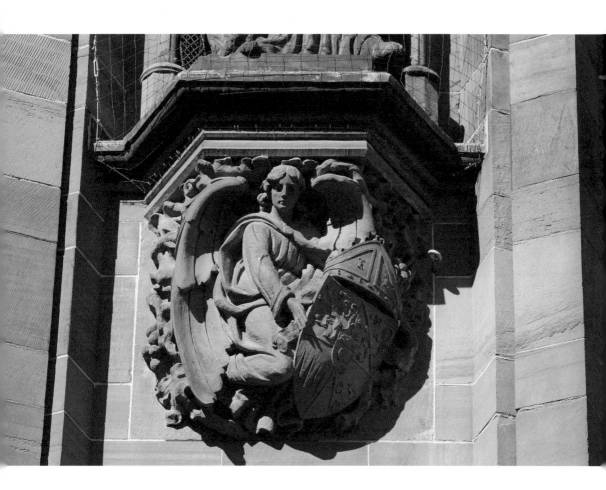

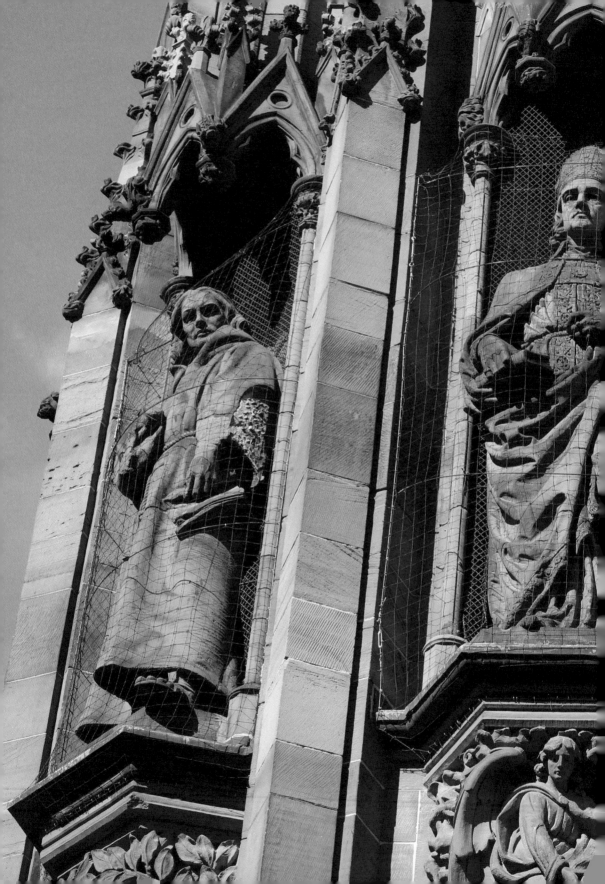

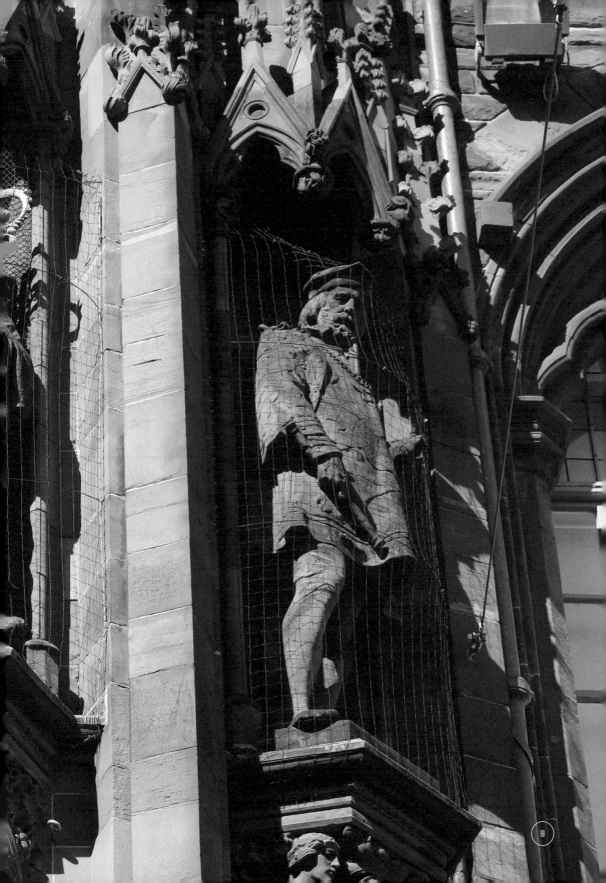

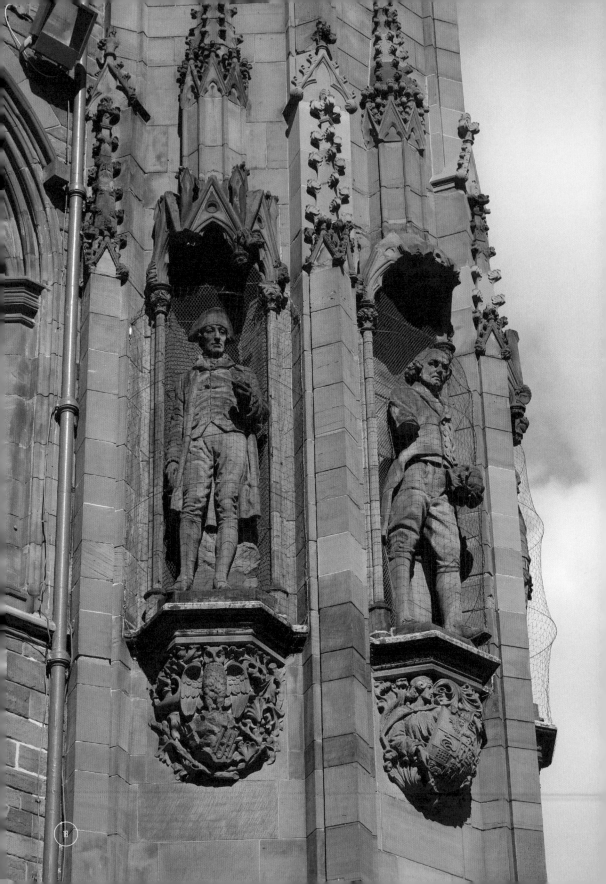

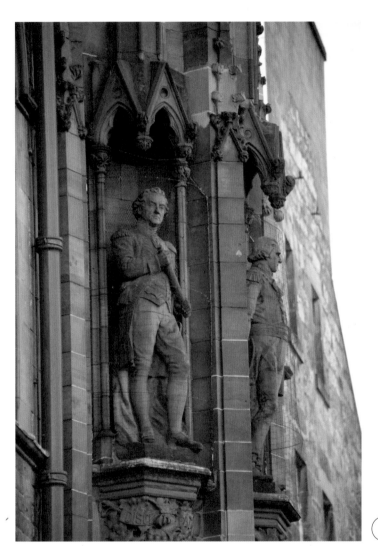

18

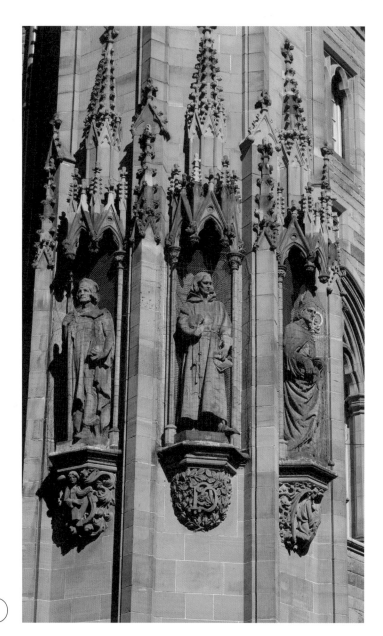

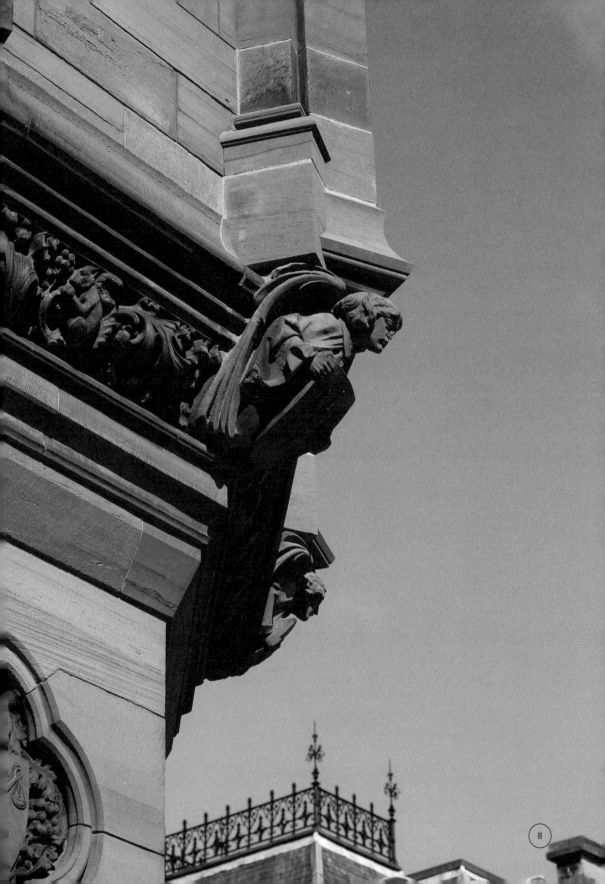

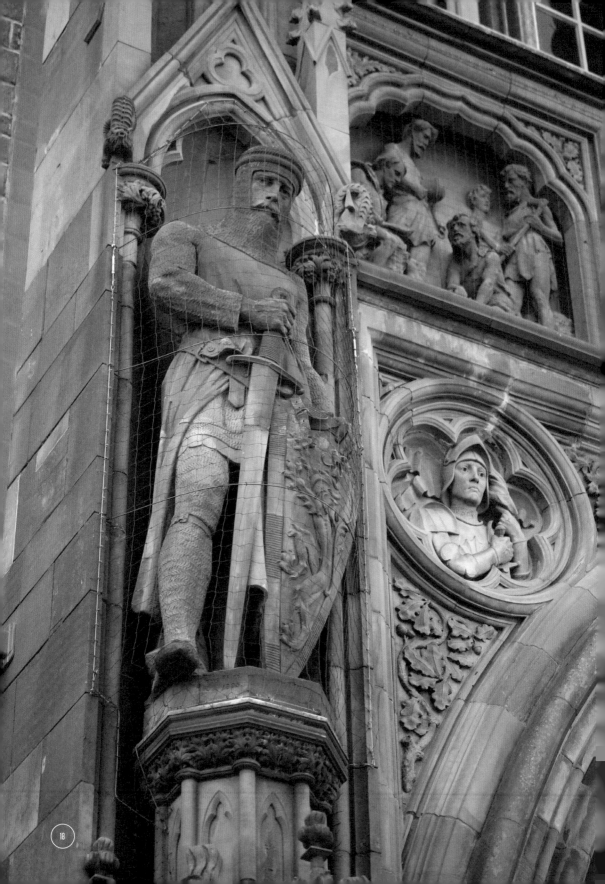

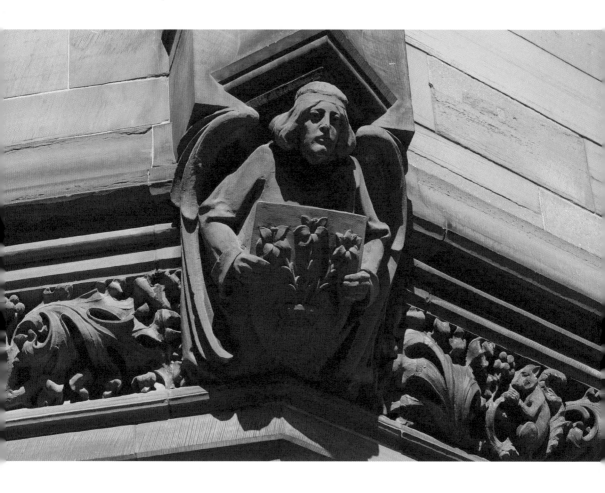

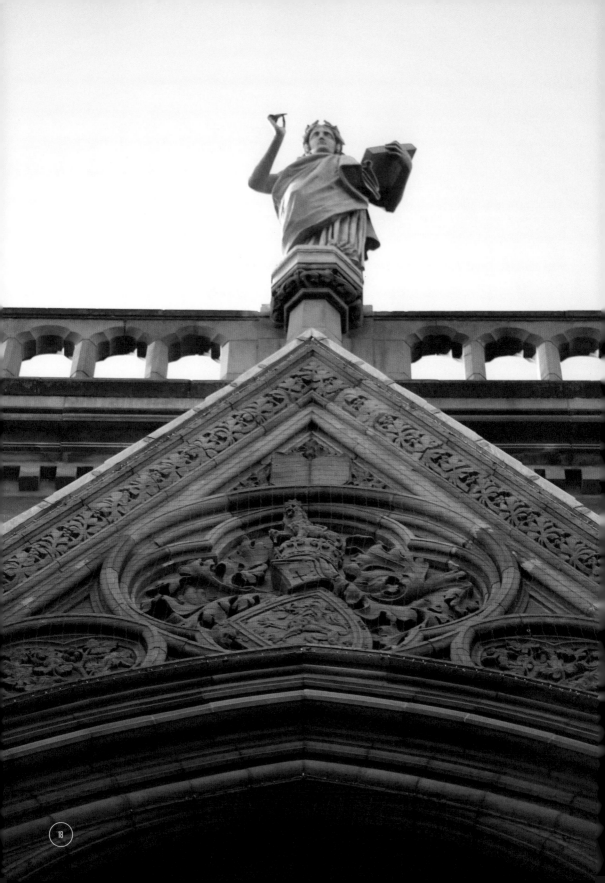

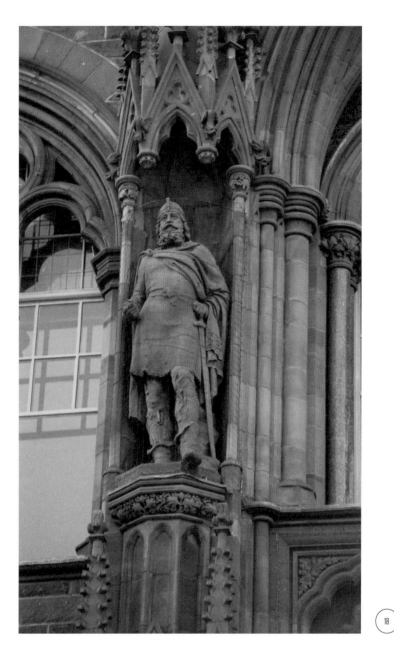

18

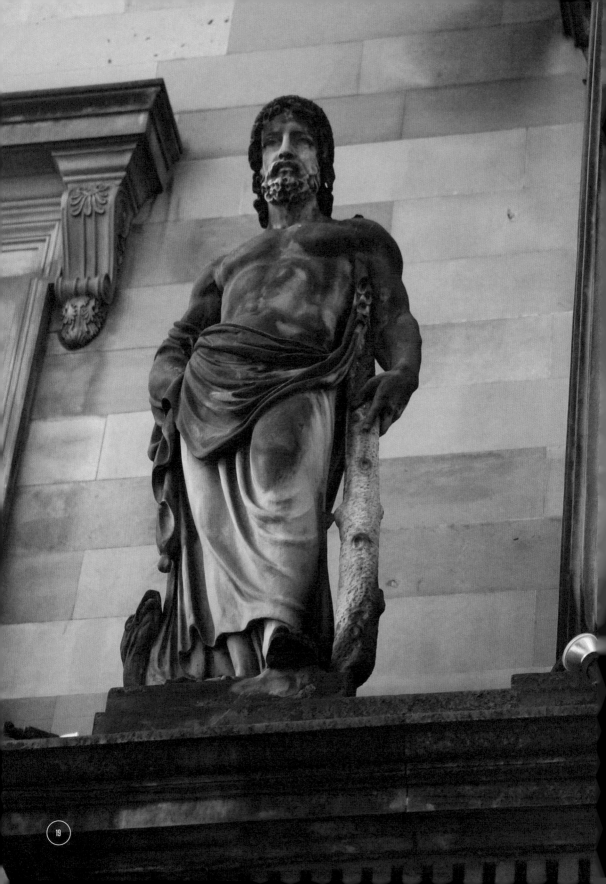

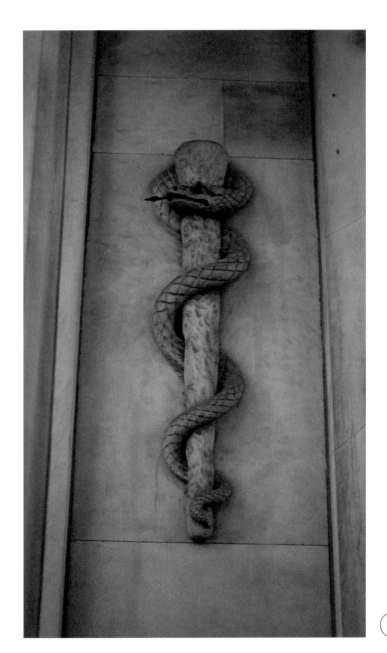

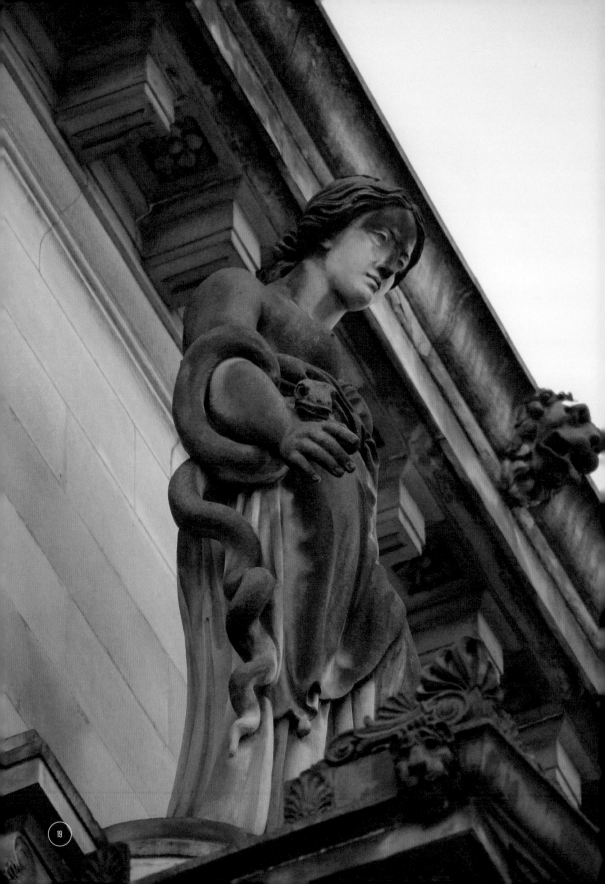

Hygieia

Dilys Rose

Don't mistake me for other famous ladies with snakes:
I am my father's daughter, share his vocation for healing but
there's only so much a goddess can do. In this Athens of the North
attend to your brooms, washrags, your scrubbing brushes.
Whoever you are put soap and vinegar to good use, lime wash,
oil of vitriol, when the mood takes you and when it doesn't.
Disease does not discriminate and never takes time off.
Be mindful of the cleansing properties of salt and laurel,
gunpowder and juniper, urea and borax, fire and water.
Strive to the keep all plagues at bay: those you know
from long acquaintance and those you dare not imagine.

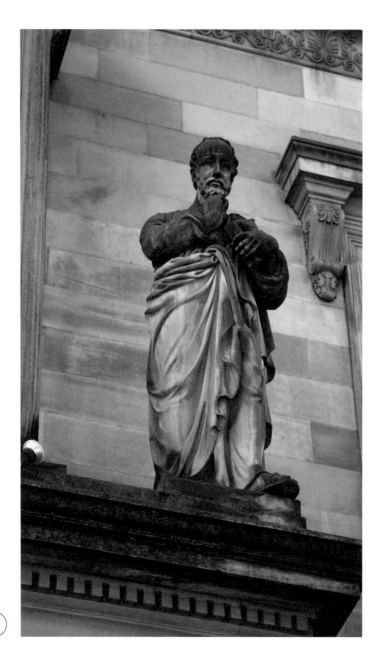

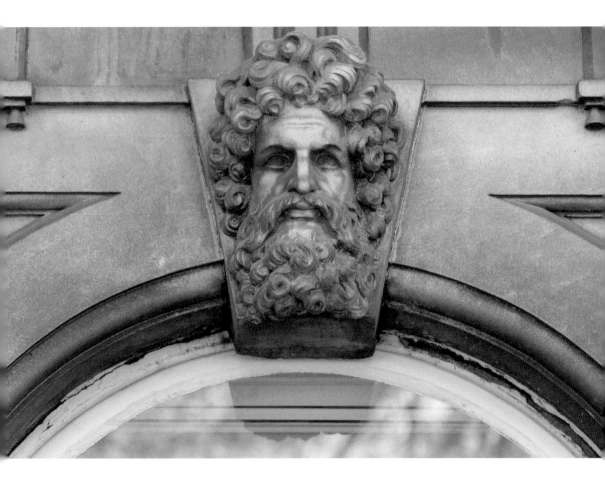

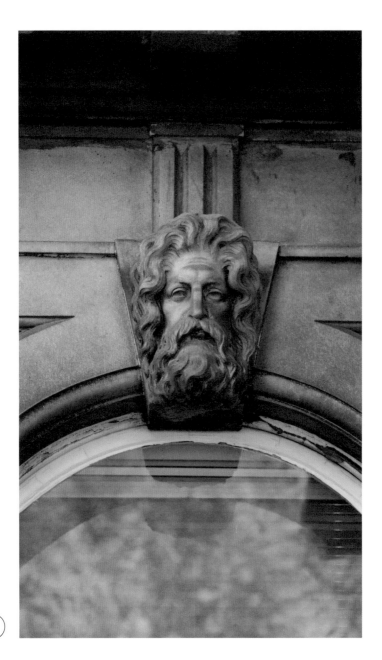

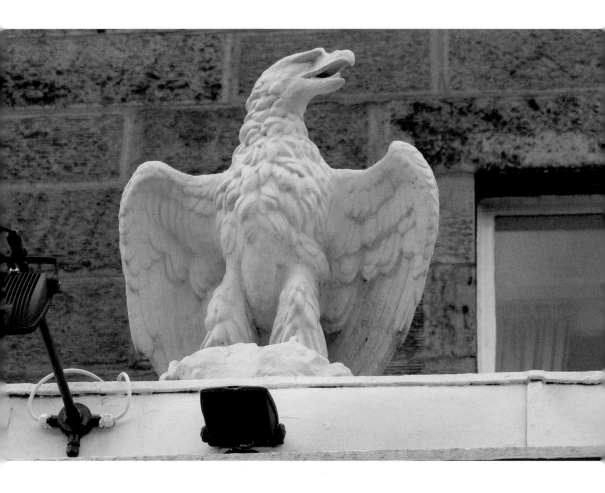

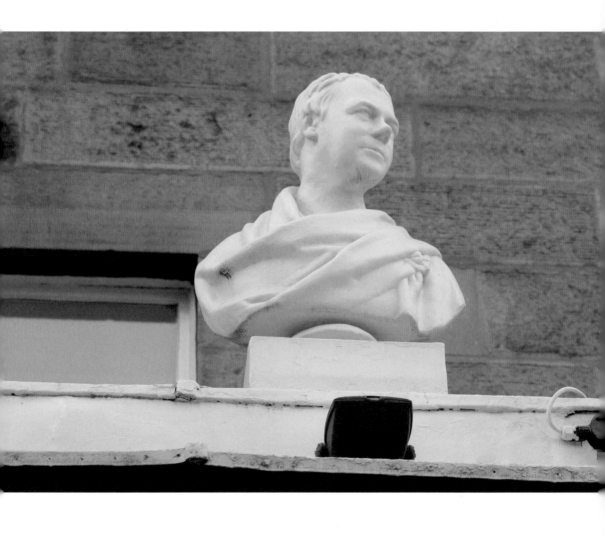

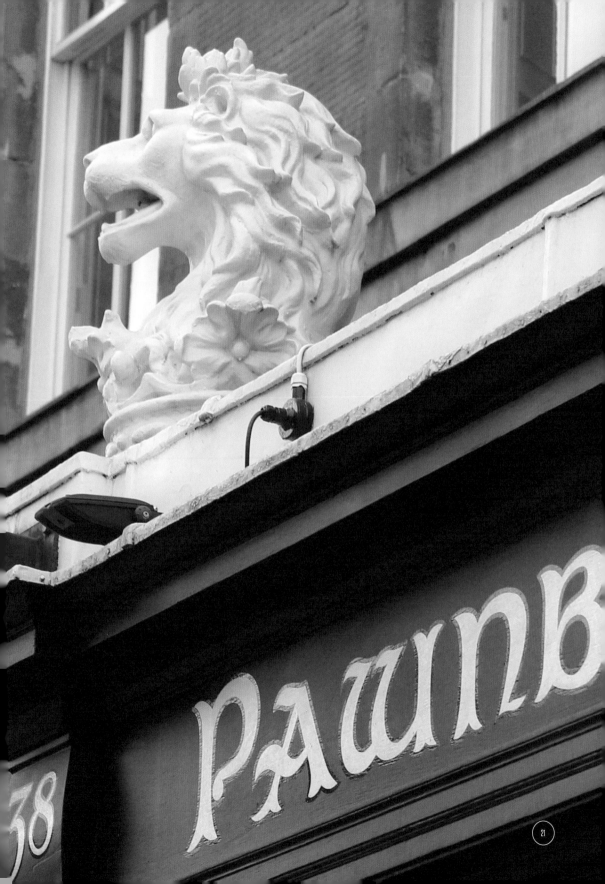

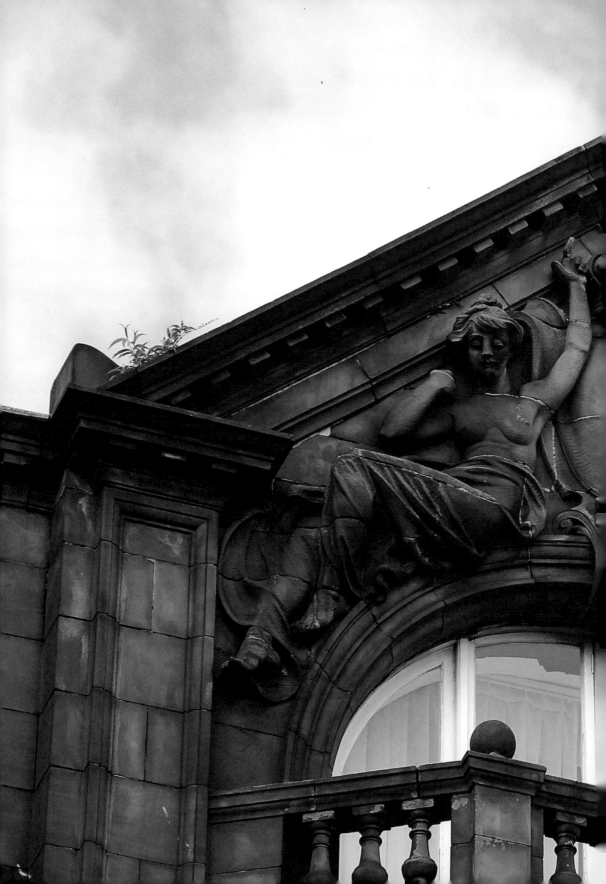

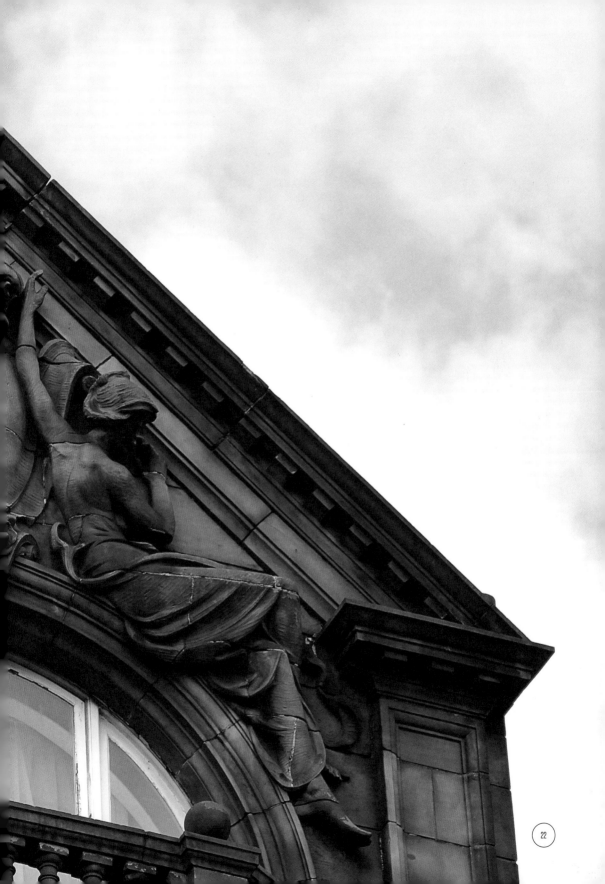

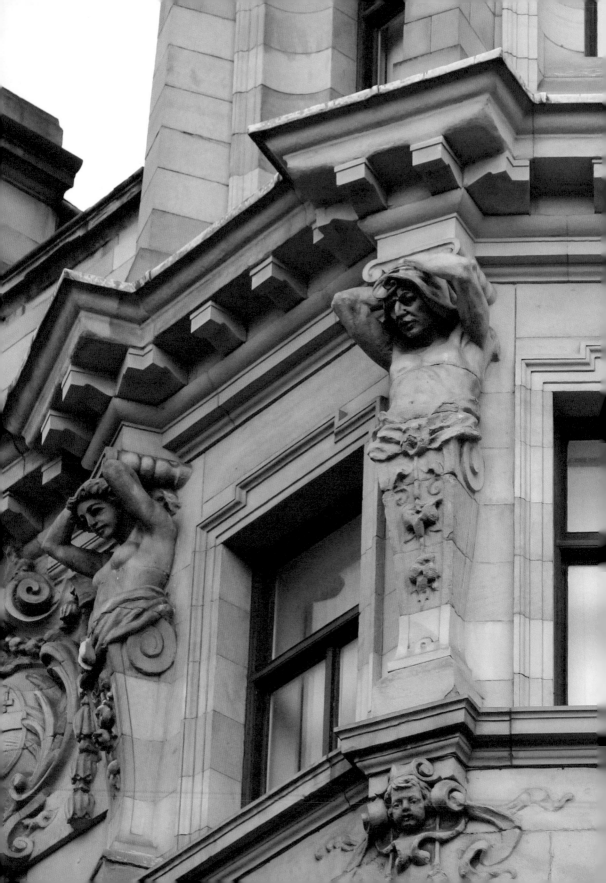

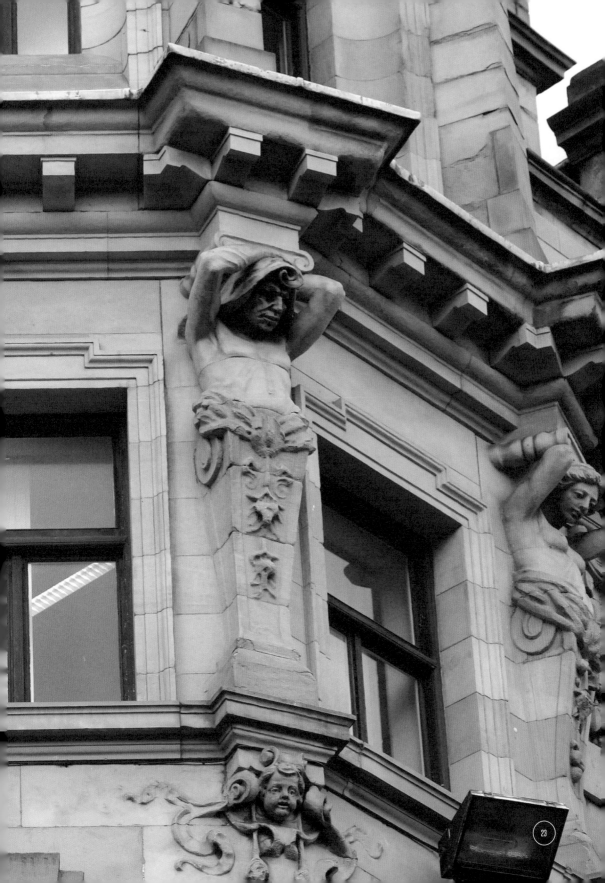

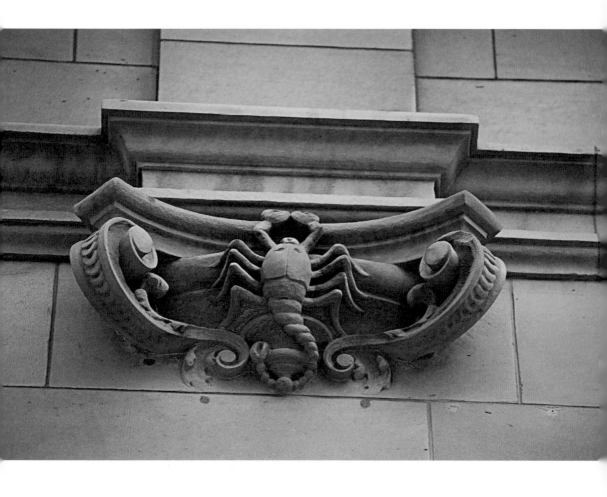

Emperor

Jane Bonnyman

His tail was a stone hook,
his pincers smooth pebbles
and his legs brittle, cold.
They positioned him
between ornate scrolls.
They said he was beautiful.

For years the winds howled,
the rains washed his still shape,
the red sun warmed his back.
No one saw the cracks appear,
the claws casting off dust,
the tiny movements of his eyes.

One night he slipped from the wall.
In his place, a black hole,
wider than the devil's mouth.

Some say he headed East.
Others know the cave where,
sluggish and alone, he waits
amongst ivory plaques
and chipped earthenware,
for scent trails, ground vibrations -
new offerings from the living.

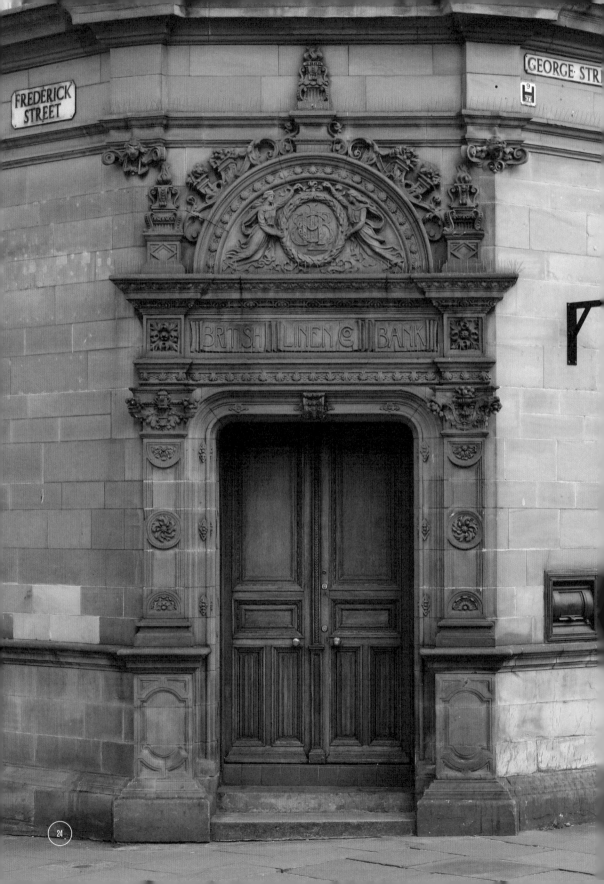

FREDERICK
STREET

GEORGE·STR

BRITISH LINEN CO BANK

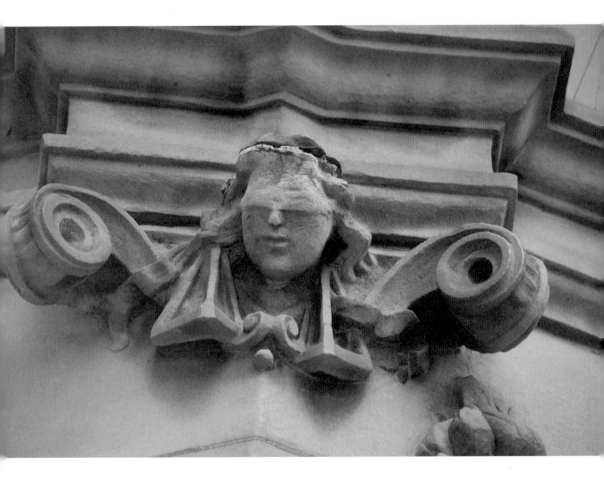

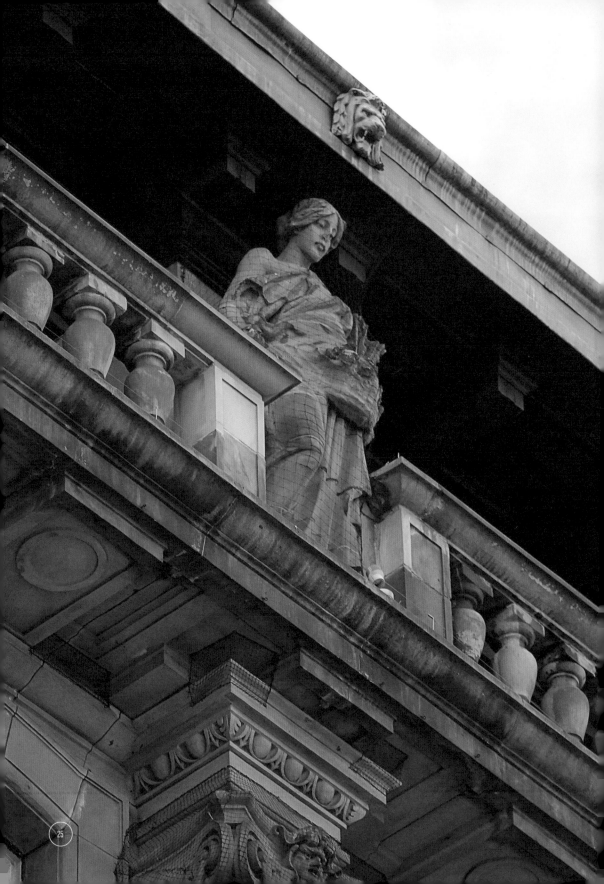

The Four Seasons

Anna Crowe

Which season is yours?
My wise acupuncturist tells me
mine is Autumn, season of nostalgia,
and my element, metal (she has felt
the iron pulsing in my veins, flowing
from my Cornish blacksmith forebears).
I'd always thought of myself as a Summer person –
petite fille du Club Méd, before
that even started, dotting about the beach
at Cavalaire or Cavalière or Les Lecques,
searching for small pink shells (I have them still);
or building sand-castles at Sète, a small ondine
smiled on, maybe, by Brassens himself.
But there's the nostalgia at work: I want to be
that girl in the sun, avec rien que moins
de costume, like 'Summer' up there, topless
but glum in the breeze from off the Forth.
Yet Autumn is clearly where I'm at, looking
back, hoping I shall have harvested enough
of what matters to see me through Winter.
And look at her, perched up there above
a Californian surf-wear outlet, smothered
from head to foot in a hooded robe that might
just be their 'Nouveau grunge'; but dreaming
still of plunging into a warm sea, naked.

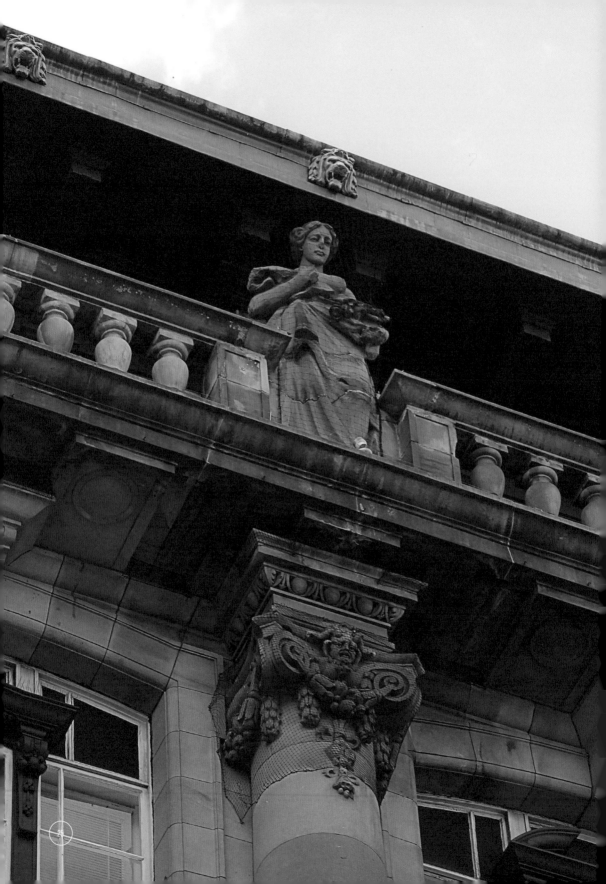

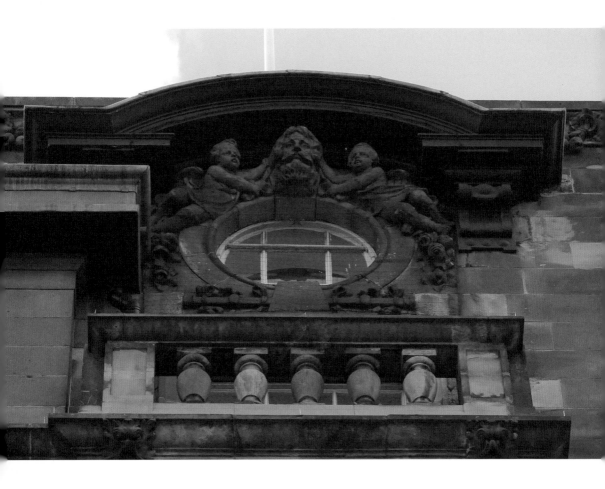

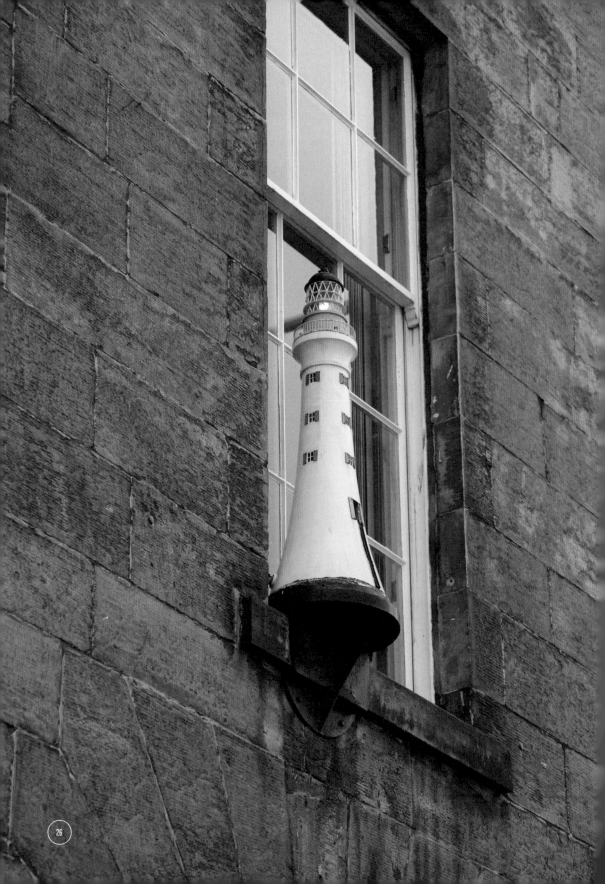

Bassey

Anna Crowe

You barely see him in this huge assemblage
of bones joined by wires and propped up on
an elegant cast-iron frame: a skeleton
of bleached spars and spavined thwarts, ribcage
a foundered barrel of staves, he stands wrecked
on the long reef of his spine. The breastbone –
that took the strain of hauling quarried stone
to the mason's yard to be cut then trekked
to Arbroath's pier – is grey, threadbare homespun.
On tiptoe you can peer right through his sight-
less orbits all the way to the vertebrae
of the great neck that rippled in the sun,
that Robert Stevenson would slap, and say,
This is the horse that built the Bell Rock Light.

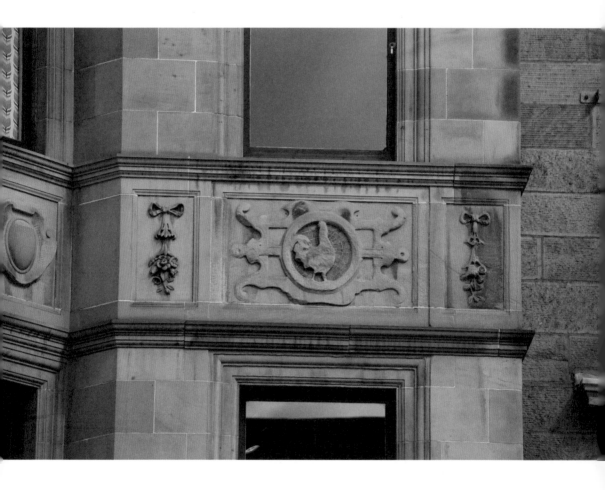

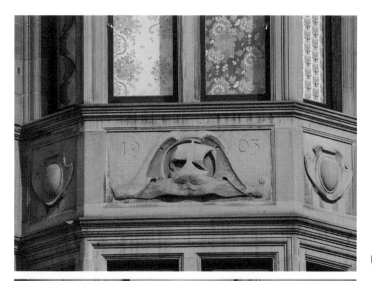

27

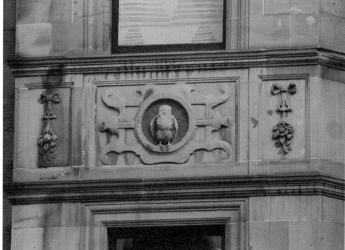

27

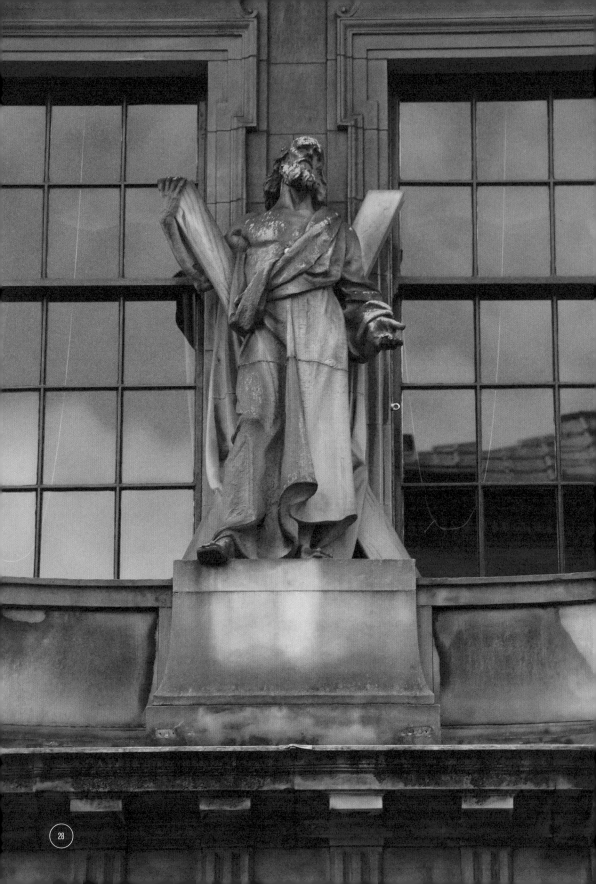

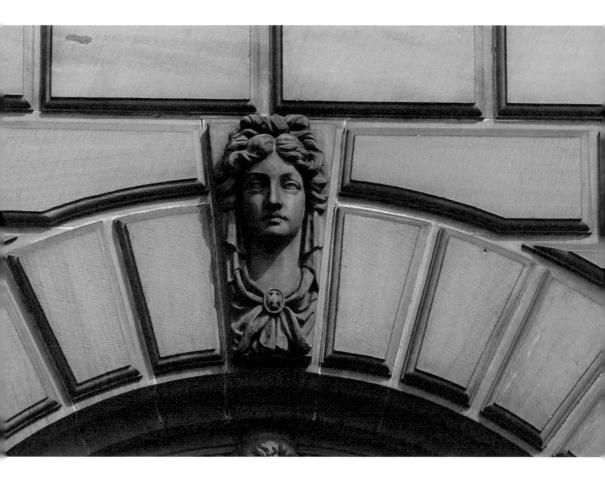

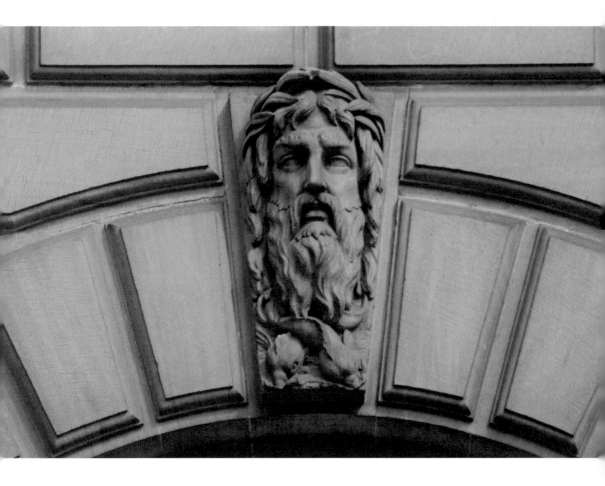

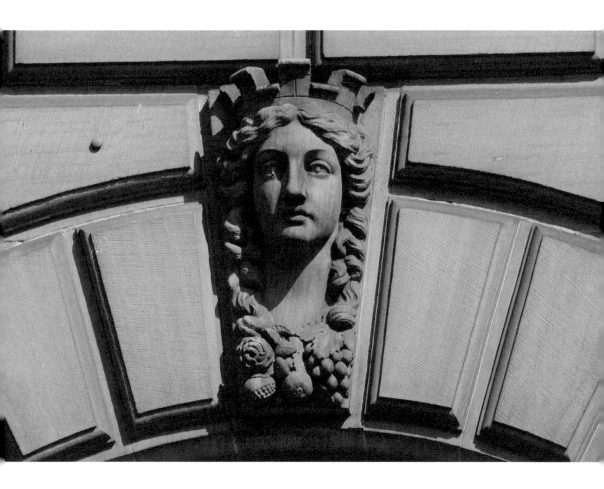

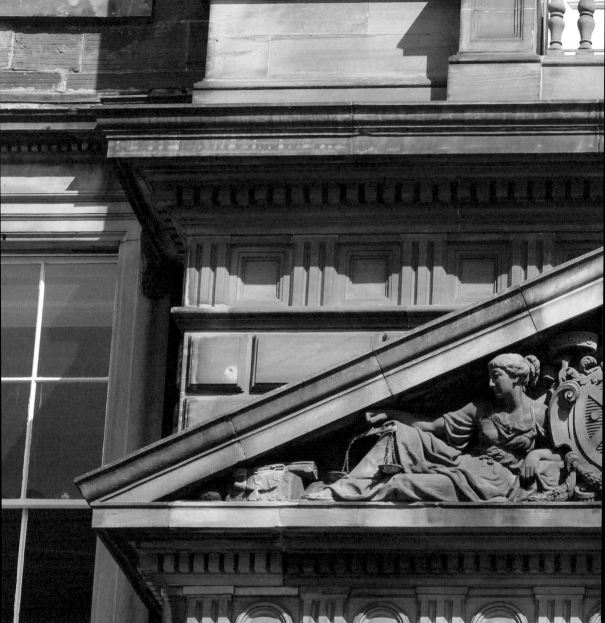

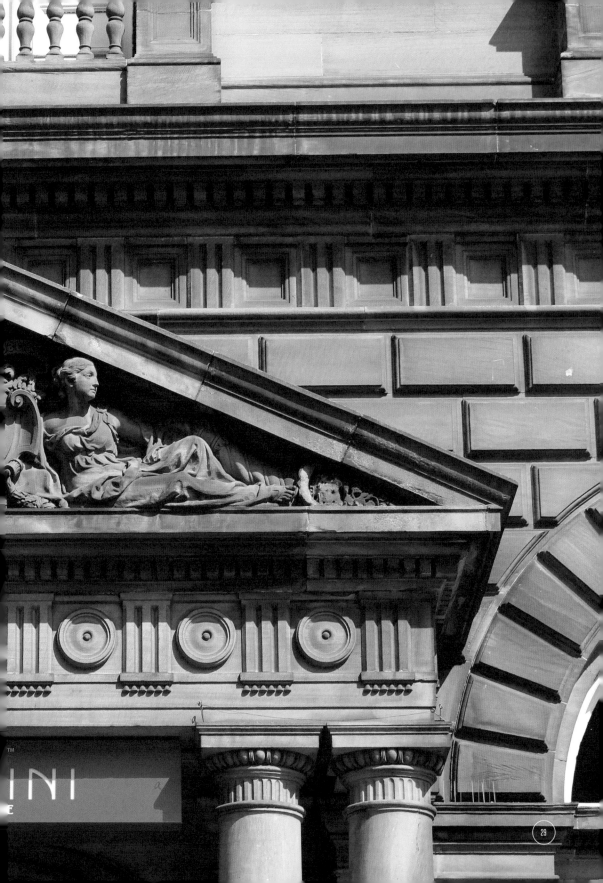

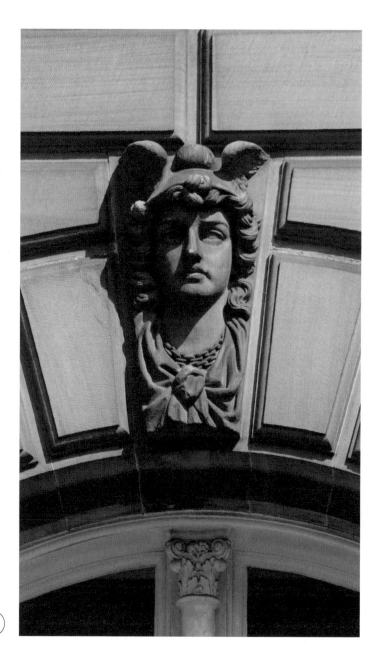

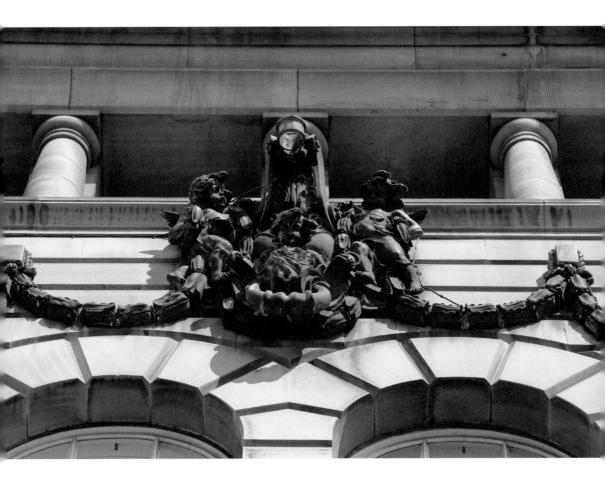

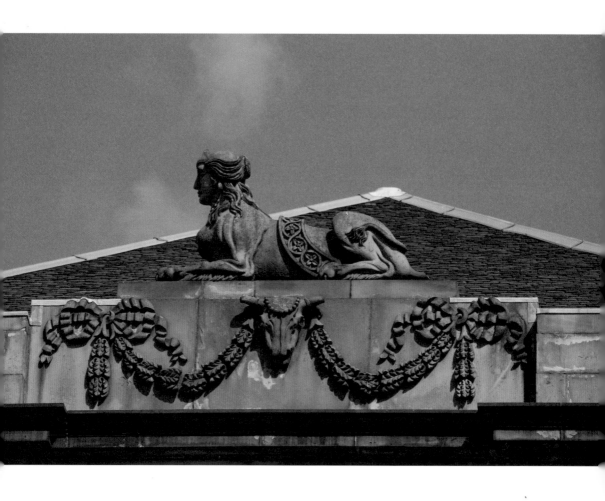

Sister Sphinxes

Dilys Rose

From our rooftop vantage points my sister and I
are perfectly placed: she looks to the east, I to the west.
(No-one would deny that Mr Adam revered symmetry.)
Our features are textbook Neó-Classical: big wistful eyes,
straight slim noses, determined chins. Our breasts, by the by,
are a disappointment: hard little apples, no sex appeal
yet our leonine haunches are sleek, our tails shapely.
Couchant Catwomen of the Enlightenment
we are particularly transfixing in late afternoon sun
and glow as only creatures made of sandstone can.
Of a summer evening, from the caravan of itinerants
in the tented village across the road, words float up
to our pyramidal roofs: poetry, politics, tales of love and death.
My sister thinks we should offer a contribution: a meditation,
an ode, an epithalamion but I say leave the bards and scribes
to their fulminations and laments and stick to our allotted task:
to greet each sunrise and sunset with equanimity and vigilance.

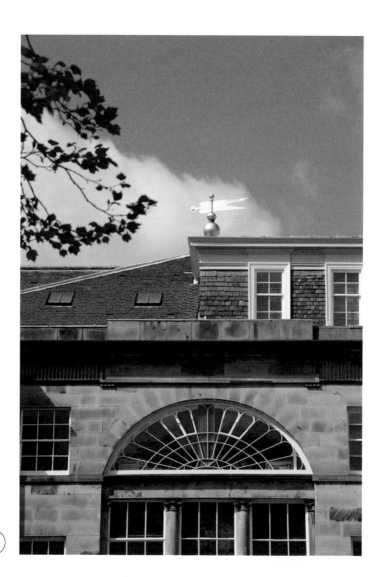

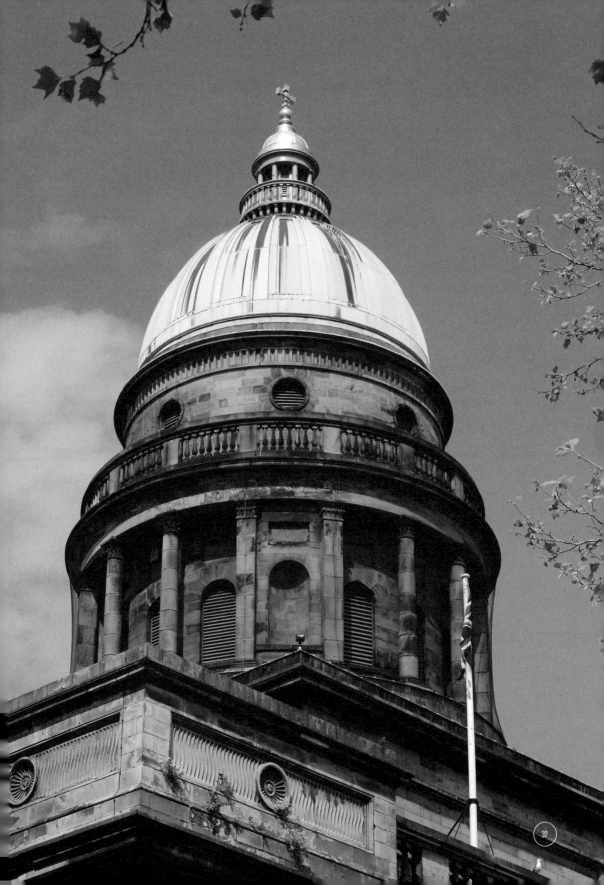

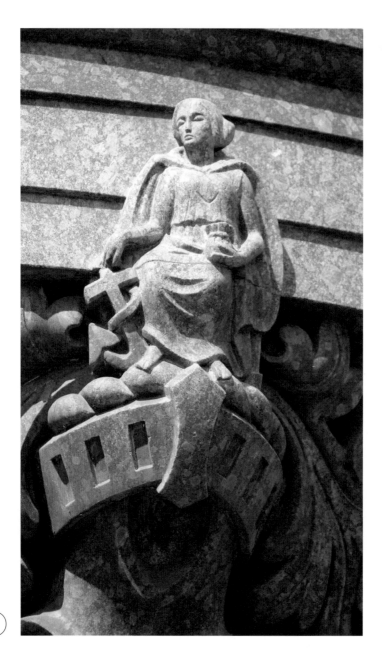

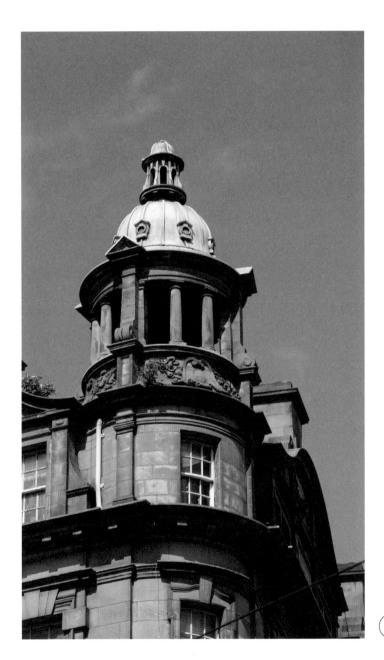

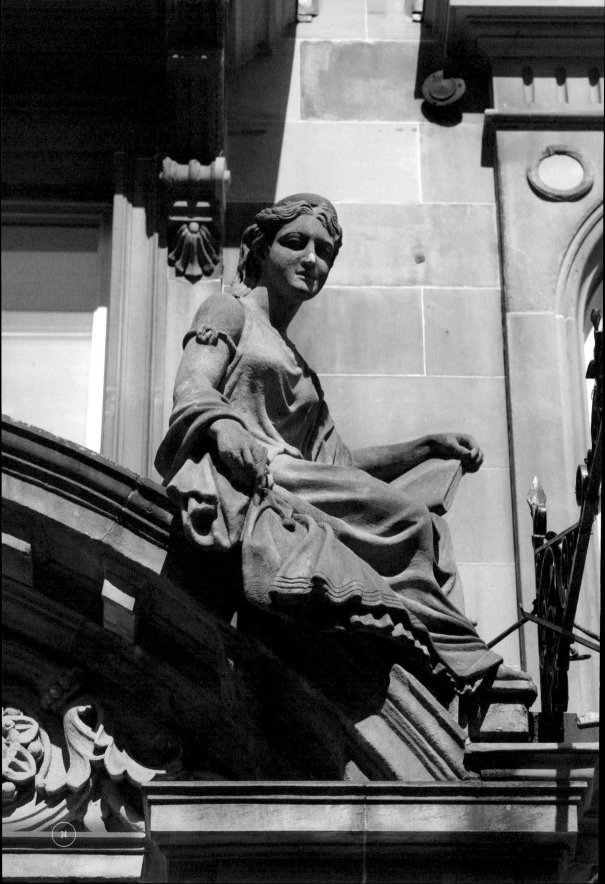

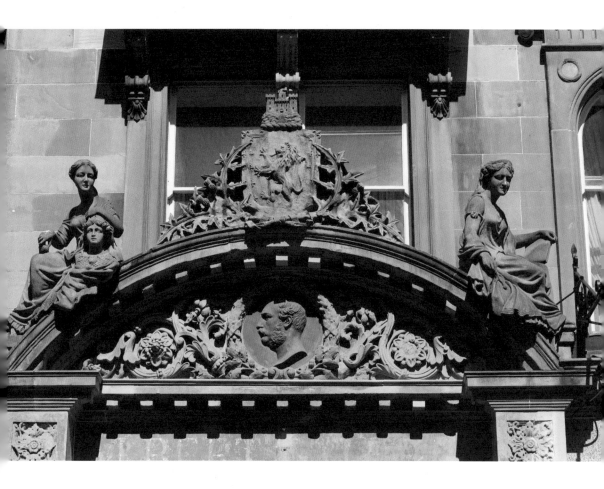

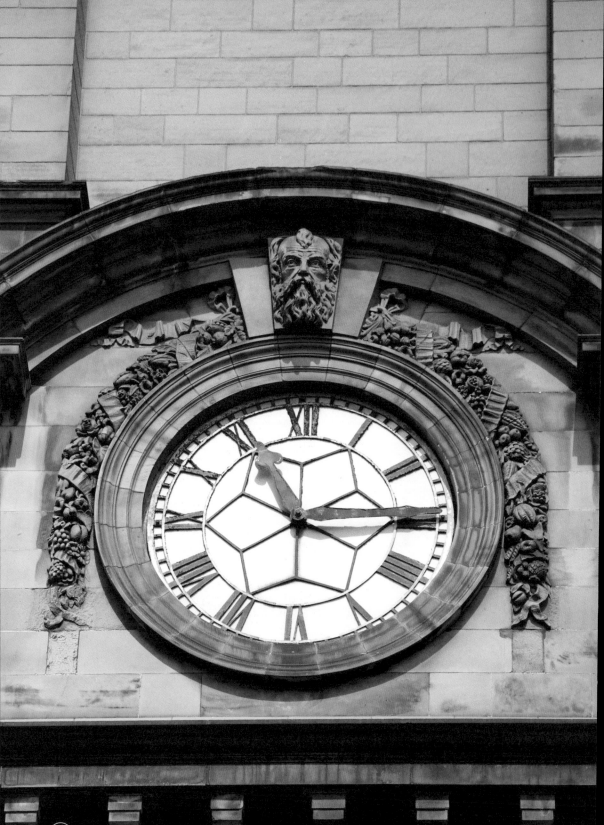

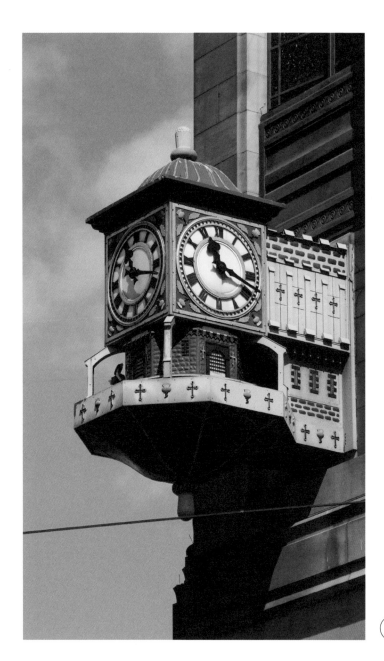

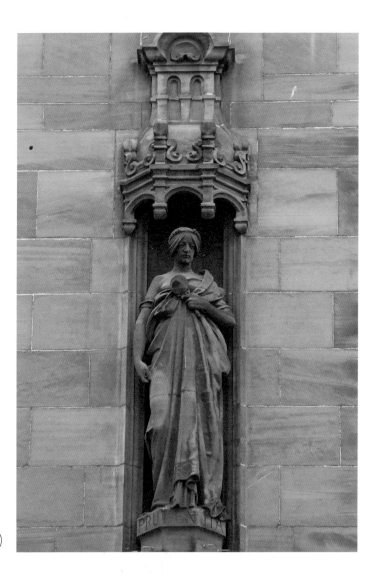

37

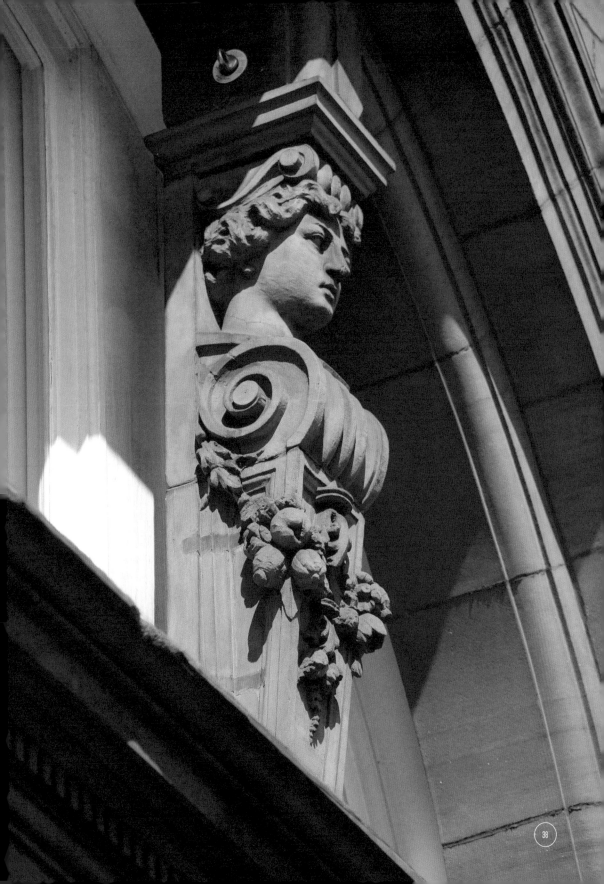

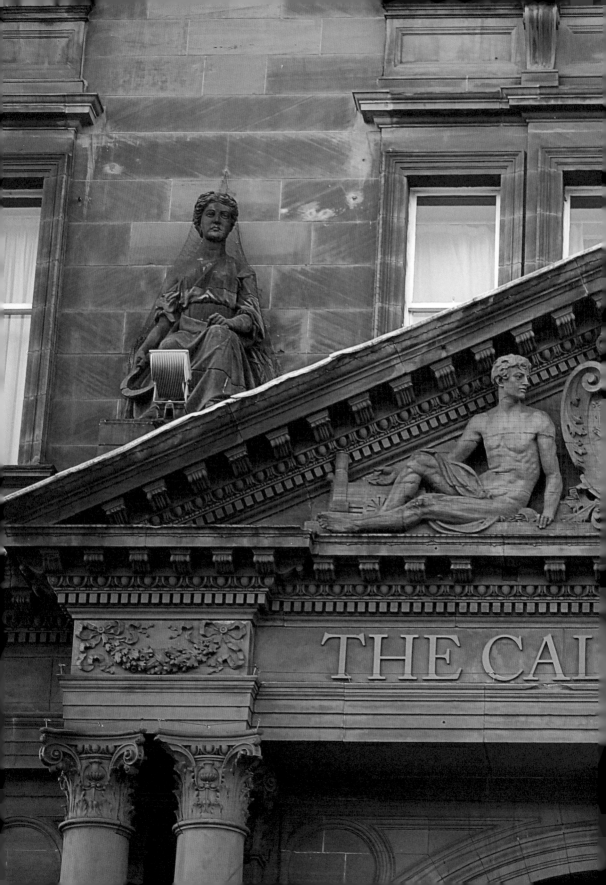

THE CAI

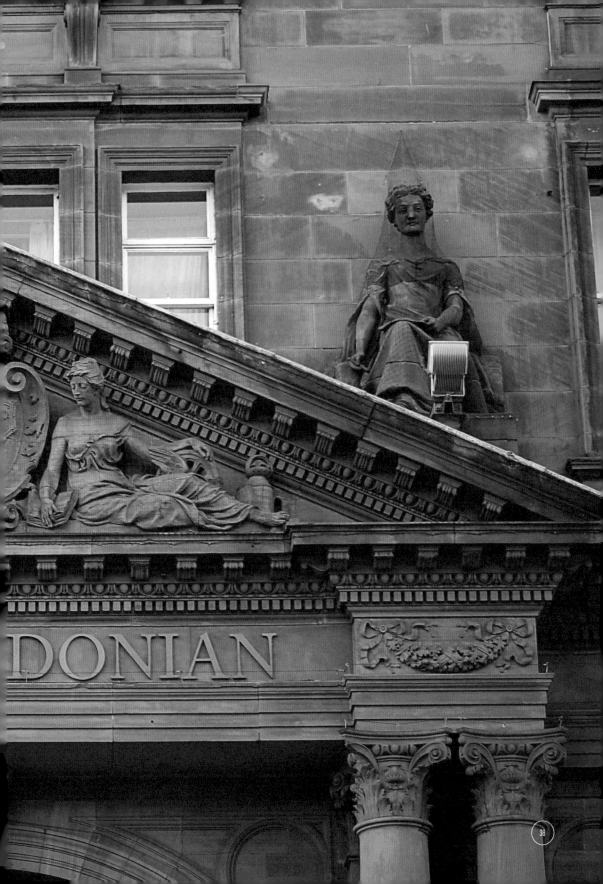

DONIAN

38

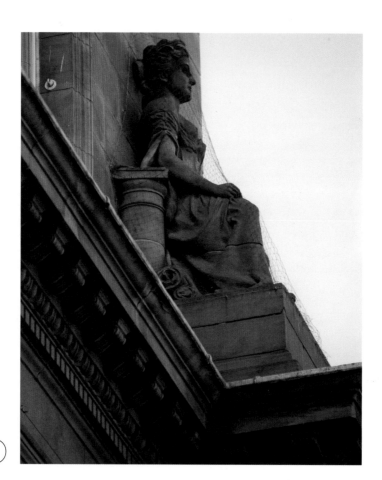

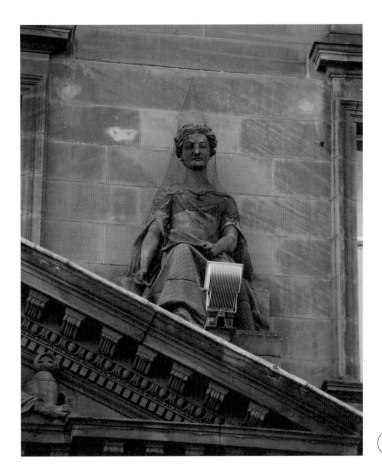

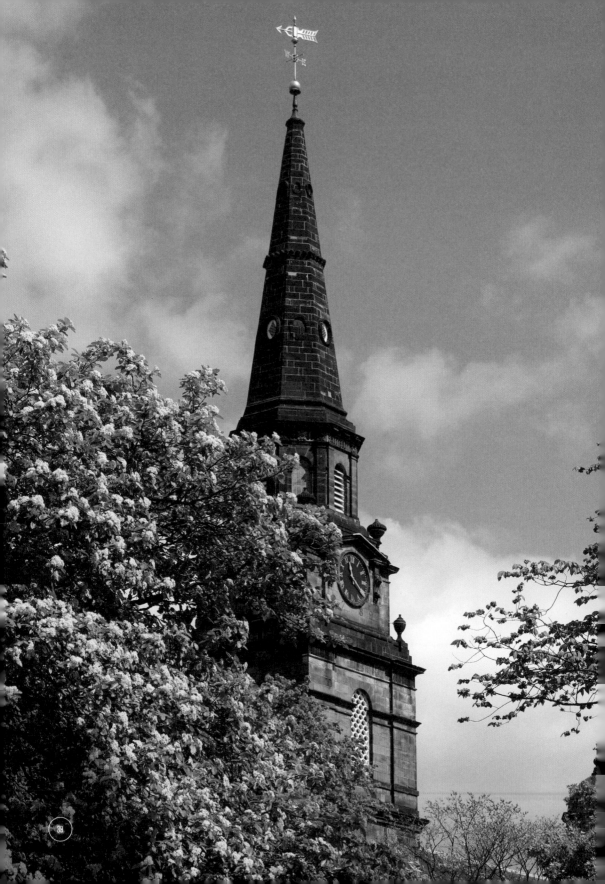

REFERENCE

1. Scott Monument,
East Princes Street Gardens
Architect: George Meikle Kemp
(1844 completed)

Kemp won the competition to design a monument to Scotland's famous author after entering under a pseudonym, worried that his lack of formal architectural qualifications would exclude him. What he delivered was a bonkers Gothic revival totem to the world's first bestselling novelist. Sadly, he died falling into Union Canal in the fog before the monument was completed. Sculptures of 64 characters from Scott's novels decorate the monument, alongside royalty and more traditional gargoyles, said to have been modelled on the ladies of Morningside. Only joking about the gargoyles. The statue of Scott himself sitting with his dog in the centre of the monument was created by John Steell, who also modelled the Sphinxes on the Royal Scottish Academy on Queen Victoria herself.

2. Balmoral Hotel, 1 Princes Street
Architect: William Hamilton Beattie
(1895-1902)

Originally named the North British Hotel, after the North British Railway who built it, until bought and refurbished in the late 1980s. I worked as a hotel porter here in the mid-80s and love the building. It has five floors beneath the Princes Street entrance and five above. Sadly the Waverley Station entrance is no longer in use. Famous guests include The Queen and Robert Maxwell, during the 1986 Commonwealth Games, Michael Palin and, most famously, JK Rowling, who

completed a number of the Harry Potter series of books in a room in the hotel, now named after her. The feature film *Hallam Foe*, starring Jamie Bell, was filmed in and around the hotel.

Intricate details can be found across the building, including multiple oriel windows, a form of bay window that projects from a wall. Two reclining male figures greet guests from above the entrance. The famous clock, visible from multiple points, is still set a few minutes fast to help people rushing for their train. And for those who look closely, there are a number of superb gargoyles just below roof level.

3. General Register House,
Princes Street
Architects: Robert Adam (1774)

Built to house the public records, the building was the first of its kind in the British Isles. Its world famous Georgian architect incorporated various details such as stone floors and brick vaults into his design, in order to protect the archive from fire and damp. The building itself has been described as having 'the character of a dignified civil servant, fastidiously dressed.'

4. 3 St Andrew's Square
Architect: Burnet, Son & Dick (1923-5)

Built as an extension for the Princes Street store Forsyth's, the architects adapted the same design to a narrower site. A large letter F is visible in the middle of the decoration.

5. 10-14 Princes Street
Architect: W Priddle (1925)

Originally a Woolworths, the building was designed by the in-house architect. Previously the site had been the location for a range of businesses including a saddlers, musical instrument makers and a cinema. Each bust that adorns the façade has a monumental but somewhat avuncular feel. To be honest, they look as if they've been pigging out on the Pick 'n' Mix.

6. Bank of Scotland,
40 St Andrews Square
Architect: David Bryce (1851-2)

Originally commissioned by the British Linen Bank to replace their former head office, this is a richly detailed, imposing building. The six Corinthian statues rising from the top represent Navigation, Commerce, Manufacture, Science, Art and Agriculture, common motifs in Victorian architecture.

7. Melville Monument,
St Andrews Square
Architect: William Burn (1823)

Controversial lawyer and Tory politician Henry Dundas 1st Viscount Melville was the namesake of this 41m high monument. Melville was the last person to be impeached from public office in the United Kingdom, for misappropriation of public funds, although he wasn't convicted. He was nicknamed the 'Uncrowned King of Scotland', such was his grip on Scottish political life. He was also a leading opponent of the abolition of slavery. The monument features a large statue of

Dundas at the top but, more interestingly, four eagles' heads protrude from each corner of the huge plinth.

8. Standard Life Building,
3-9 George Street
Architect: JM Dick Peddie & G Washington Browne (1897-1901)

Sculptor: John Steell, Anon.

Built to replace a previously demolished building, dating back to 1839, from which the original pediment remains. The pediment sculpture, designed by John Steell, represents the Wise and Foolish Virgins, from the Gospel of St Matthew, it being assumed no doubt that the five wise ones would have insured themselves. A frieze of naked children with swags of flowers and fruit, as symbols of abundance, also run round the whole building. The modern annex was built in 1975, the fabulous bronze relief on the same religious subject matter being added in 1979, although at the moment the sculptor is unknown. In this instance the five wise virgins are identical, in a row, bare-breasted. To their left are the five foolish virgins, separate and clothed, in attitudes of despair and anguish. The frieze is read from left to right. The Foolish Virgins represent: Wistfulness, Self-absorption, Panic, Despair and Procrastination. The Wise Virgins, 'being perfect, their transcendence has rendered them identical and equal'. Robert Palmer would approve.

9. The Capital Building,
12-13 St Andrews Square
Architect: Leslie Graham Thomson (1939)

Sculptor: Alexander Carrick

The bronze figures flanking the entrance to the building represent 'Insurance' and 'Security', symbols of the aims of The Caledonian Insurance Company for whom the building was originally designed. The figures of the man and girl is titled 'Safety' and the group of women and children 'Felicity.' Both are tremendous examples of the period.

10. St Andrew's and St George's West Church, 13-17 George Street
Designer: Major Andrew Frazer (1782-4)

The building was originally built without the steeple, which was added in 1787. The church was the setting for the Disruption of 1843, when ministers from the Church of Scotland walked out and formed the Free Church of Scotland. The steeple clock features a haunting mask of Old Father Time with garlands, a common decorative detail of the time.

11. The Dome,
14 George Street, Edinburgh
Architect: David Rhind (1846)

Originally built for the Commercial Bank of Scotland, the building is now a restaurant and bar. The triangular pediment above the entrance contains a group of figures that represent, from left to right Navigation, Agriculture, Plenty, Caledonia, Enterprise, Merchandise and Science. As crowded as the bar on a Friday night.

12. Royal Scottish Academy,
77 Princes Street
Architect: William Henry Playfair (1825-9)

The north pediment of the building contains a statue of Queen Victoria and a pair of sphinxes, all carved by John Steell. Queen Victoria sat for John Steell, appointed Sculptor to Her Majesty the Queen in 1838, five times at Windsor Castle, from which he prepared a clay model.

13. Royal Society of Edinburgh,
55 Hanover Street
Architects: William Burn and David Bryce (1843)

Former New and Old Edinburgh Life Assurance Offices, occupied by the Royal Society in 1909. The draped female figure atop the dome is holding a sheaf of corn in the crook of her right arm and a palm leaf in her outstretched left hand. A palm leaf was often used as a symbol of peace or victory, while corn symbolized agriculture and bounty.

**14. Trustee Savings Bank,
28-30 Hanover Street**
Architect: William Paterson of Oldrieve,
Bell & Paterson (1939-40)

The roundels above the two entrances
contain the arms of the TSB, a two-
towered castle, flanked by bound oak leaves.
The other roundels contain the arms of
Leith, Edinburgh and Musselburgh, the
three burghs where the bank operated.
Edinburgh's contains the well-known
3-towered castle; Musselburgh's three
mussels and anchors while Leith's more
religious arms depicts the Virgin and Child.

15. Merchant's Hall, 22 Hanover Street
Architect: David Bryce Jr (1865-6)

The coat of arms depicting a sailing
ship and two sea unicorns represent
the mercantile origins of the Merchant
Company, for whom the building was
built. The sea unicorns combined with the
phrase 'terrique marique' (by land and by
sea) symbolize Edinburgh's history of trade
by sea.

16. Jenners, 47-52 Princes Street
Architect: William Hamilton Beattie
(1895)

The original building of this department
store, dating back to 1838, burned down
in 1892 and was replaced by this supposed
fireproof structure. Technical innovations in
the new building included electric lighting
and hydraulic lifts. The centrepiece of the
store is a large, top-lit gallery. The figures
carved into the exterior symbolize the
female staff and customers and were paid
for by owner Charles Jenner.

**17. 70-71 Princes Street
(currently Great Scot)**
Architect: Hippolyte J Blanc (1886)

Formerly Crawford's Café. In the centre of
the gable, a panel depicts the Edinburgh
coat of arms, a three-towered castle flanked
by a maiden and a female deer, with a Lion
Rampant above. The castle has long been a
symbol of Edinburgh. Next door to the east
was the grand North British Mercantile
Insurance Company HQ until the building
was demolished in the 1960s to make way
for British Home Stores.

**18. Scottish National Portrait Gallery,
1 Queen Street**
Architect: Sir Robert Rowand Anderson

Sculptor: W Birnie Rhind (1885-90)

Intended for the joint use of the Portrait
Gallery and the National Museum of
Antiquities, the building was financed by
J.R Findlay, the owner of the Scotsman
newspaper, to a cost of £50,000. Its
influences are as broad as Gothic Revival,
Venetian palaces and the Arts and Crafts
movement. Birnie Rhind's exterior
sculptures were added over a number of
years in the 1890s. Allegorical figures
depicting History, Industry, Religion,
Fine Arts and Science stand alongside the
Scottish arms, while a number of notable
Scots are recognizable, including the
Calvinist firebrand John Knox. William
Wallace and Robert the Bruce guard the
entrance. The Gallery building also has a
collection of wonderful gargoyles.

**19. Royal College of Physicians,
9 Queen Street**
Architect: Thomas Hamilton

Sculptor: Alexander Ritchie (1844)

The use of this building can be seen in
the three sculpted figures around the
entrance. All are connected with healing
and medicine, with the goddess of health,
Hygeia, standing above figures depicting
her father, Aescalpius, the god of medicine
and the more mortal Hippocrates, the
ancient Greek physician and namesake of
the Hippocratic Oath.

20. 13 Queen Street
Architect: WL Moffatt (1860)

Six bearded male keystone heads with bags
of personality decorate this neo-classical
building. Keystones are essential to the
construction of buildings as they lock all
the other stones into position and are often
sculpted as decorative figures or animals for
a more pleasing design. These guys look
like members of the Kings of Leon.

**21. Duncanson and Edwards Pawnbroker,
38 Queen Street**
(1780s)

38 Queen Street is designed differently to
the other tenements on this, the grandest
of New Town streets, suggesting that they
were custom-built. While the building is
Georgian the shop front is late Victorian.
A bust of Sir Walter Scott rests on the
shop front canopy, alongside lion heads
and eagles. A bust of Burns, cast from an
original by Steell, was removed in 1995.
Where it went, nobody knows.

**22. Frederick House Hotel,
38-42 Frederick Street**

Architect: James B Dunn & James L
Findlay (1903)

Formerly Victoria Chambers, this was the
home of the improbably named National
Boiler and Vulcan Insurance Group. Don't
tell the Trekkies. In the two outer bays and
in the gables are semi-naked female figures
seated on arched windows. Between each
pair of figures is a blind cartouche and a
crown. Below each cartouche, at the top of
the window arch, is a lion mask.

**23. Nationwide Building Society,
71 George Street**

Architect: TP Marwick (1908)

Formerly the location for the investment
company Gresham House, the building
is decorated with coats of arms from
various cities. These include London's, a St
George's Cross and a trusty sword of truth;
Glasgow's is the tree, fish, bell, bird and
ring and the ship, stork and castles belongs
to Stirling. Four figures stand between the
windows of the 3rd floor; two male and
two female. Below each figure is a child's
head. Around the base of the dome are
garlands of fruit. In the spandrels of the 4th
floor windows, below the corner dome, is
foliage. Finally there is a badly eroded male
head above one of the top floor windows.
Who can he be?

24. 69 George Street (1905)

Formerly housing the British Linen
Bank, currently the retailer Fat Face, the
bank's ornate seal can still be seen above
the entrance. Carved signs of the Zodiac
dot the building's exterior. The scorpion
looks lifelike enough to jump down and
sting some passing gent in the seat of his
red trousers.

25. 78-80 George Street

Architect: Sir John James Burnet (1903-7)

Originally built for the Professional and
Civil Service Supply Association, the
building is decorated with four female
figures symbolizing the Four Seasons.
Spring holds an urn; Summer, with flowers
in her hair is dressed for hotter weather
and holds fruit in her arms; Autumn holds
a wheat sheaf in her right arm, while the
cloaked and hooded Winter completes
the scene.

**26. Commissioners of Northern
Lighthouses, 82-84 George Street**
(late 18th Century)

Just like its full size equivalents, the
ornamental lighthouse atop this building
flashes its beacon of warning 24 hours a day.
It was added during major remodelling in
1973. Established in 1786, The Northern
Lighthouse Board is responsible for all 201
lighthouses across Scotland.

27. 89 George Street

Architect: Cousin, Ormiston & Taylor

Sculptor: WS Cruikshank & Sons (1903)

Formerly housing James Gray and Sons'
Department Store, a large royal coat of
arms can be seen above the entrance,
reminding us of Gray's royal warrant to
supply cleaning products, stoves, grates,
lamps and oils to the Royal Family.
Intriguingly, the owl with red mosaic
surround, the ship, and the cockerel with
blue mosaic surround on the façade, add
an Arts and Crafts touch to an otherwise
Renaissance style building.

**28. Freemason's Hall,
96-98 George Street**

Architect: A Hunter Crawford

Sculptor: HS Gamley (1910-12)

Described by the *Builder* as a design that
'lacked courage', the stand-out detail is
the monolithic figure of St Andrew above
the entrance. A restrained exterior belies a
lavish interior.

**29. Former Bank of Scotland,
101-103 George Street**

Architect: JM Dick Peddie (1883-85)

The original use of the building can still be
seen in the Bank of Scotland arms above
the entrance. Two reclining female figures
flank a shield decorated with a saltire. One
holds a set of scales, symbolizing Justice,
the other a cornucopia, the traditional
symbol of abundance.

30. Church of Scotland HQ,
121 George Street
Architect: Sydney, Mitchell and Wilson
(1909-11)

Designed as offices for the newly formed
United Free Church of Scotland, which
subsequently amalgamated with the
Church of Scotland in 1929. The design
was not well received and led to the
retirement of its designer. The coat of arms
above the entrance contains images from
two Bible passages: the burning bush from
the story of Moses and the dove holding
an olive leaf from the story of Noah. The
burning bush has been the official logo of
the Church of Scotland since 1958.

31. 10-15 Charlotte Square
Architect: Robert Adam 18th Century

Charlotte Square was the last section of
the New Town to be built and the only one
designed as one unified piece. Formerly
a doctor's surgery, you can see the the
beautiful uniformity of the design.

32. National Records of Scotland, West
Register House, Charlotte Square
Architect: Robert Reid (1811-14)

Originally St George's Church, the final
cost came in well above the estimate,
although trams were not included. The
design of the dome is based on the dome of
St Paul's in London.

33. Santander Bank,
2-4 Shandwick Place
Architect: Sydney Mitchell & Wilson
(1901)

This building has housed various banks
since its construction, and the shield
above the entrance indicates its mercantile
origins, with a female figure sitting holding
a money bag and anchor, above the figure
of St Andrew.

34. Albert Buildings,
22-30 Shandwick Place
Architect: Hamilton Beattie (1876-77)

A bust of the building's namesake can be
seen above the entrance, while two female
figures representing Sculpture and Poetry
flank the pediment. Sculpture holds a bust
of a girl in her hand, while Poetry grips a
book. The building was originally built to
house the works of contemporary artists.

35. St George's West Church,
58 Shandwick Place
Architect: David Bryce (1866-69)

The bell tower was added in 1879-81 and
was designed by R. Rowand Anderson. The
design was based on the bell tower of the
Church of San Giorgio Maggiore on the
Venetian island of the same name.

36. Frasers Department Store,
146 Princes Street
(c. 1935)

This handsome clock lends grandeur to an
otherwise austere Art Deco department
store, previously the sole Scottish outpost
of Binns Ltd, a Sunderland based retailer.
The building began life as Maules, another
department store. 146 Princes Street was
bought by House of Fraser in 1953 but
retained the name Binns for many years.
The clock was added by the new owners
after the purchase.

37. Tiles Bistro, 1 St Andrews Square
Architect: Alfred Waterhouse & Son
(1892-97)

Sculptor: W Birnie Rhind (attr.)

Although now a bar and bistro, this
building was originally built for the
Prudential Assurance company. A statue
of Prudentia remains at the corner of the
building, gazing down and urging restraint
for all entering on a Saturday night.

38. Caledonian Hotel, Lothian Road

Architect: Kinnear & Peddie (1892-1903)

Originally built as part of Caledonian
Railway Station, which closed in 1965.
Four allegorical female figures can be seen
above the ground floor. Engineering holds
an anvil and hammer, while Agriculture
holds a scythe in her right hand and has
rather fetching wheat stalks in her hair.
To her right sits Commerce, with a large
cotton bale tied to her. Arts completes the
scene, and should be holding a brush in her
right hand, but it is now missing.
I blame Agriculture.

39. St Cuthbert's Parish Church, Lothian Road

Architect: Hippolyte J Blanc (1892-5)

A church was first constructed on this
site in 1127, which after the Reformation
became known as the 'Little Kirk.' By 1888
the church had become unsafe and it was
eventually decided that it should be rebuilt.
The present building is a reconstruction of
the 1774 church, retaining the Georgian
spire by Alexander Stevens of Tollcross, but
no trace of the medieval church remains.
Famous occupants of the churchyard
include Thomas de Quincey, opium
eater extraordinaire, the artist Sir Henry
Raeburn, Alexander Nasmyth, the painter
who created the most famous portrait
of Robert Burns, and Charles Darwin's
uncle. The church also has one of only
three stained-glass windows in the UK by
Tiffany's on New York, this one featuring
David and Goliath.

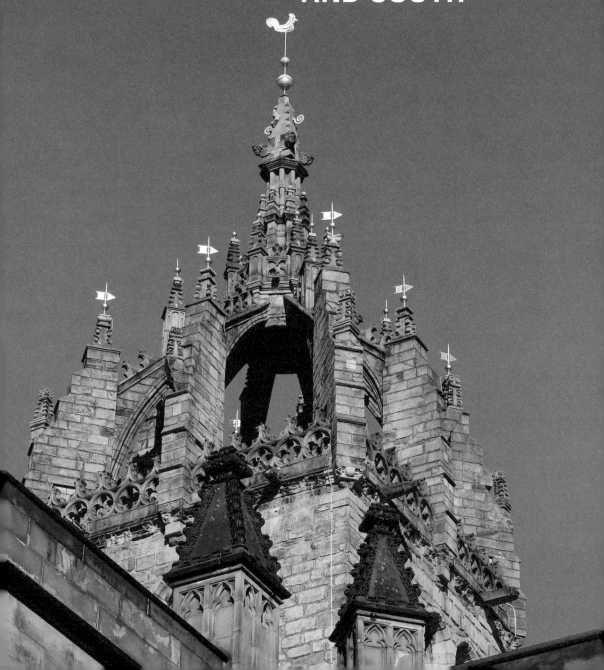

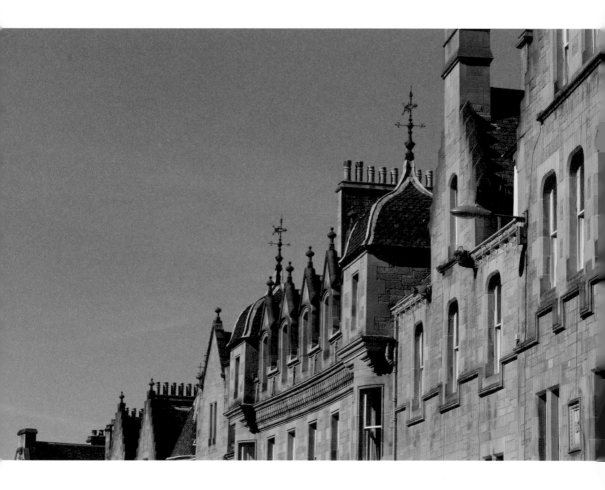

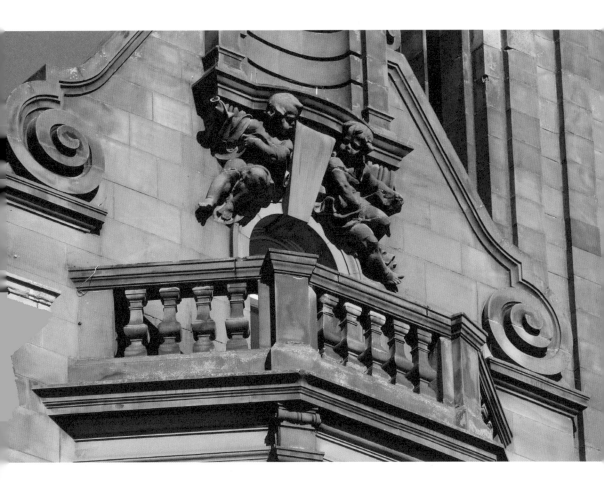

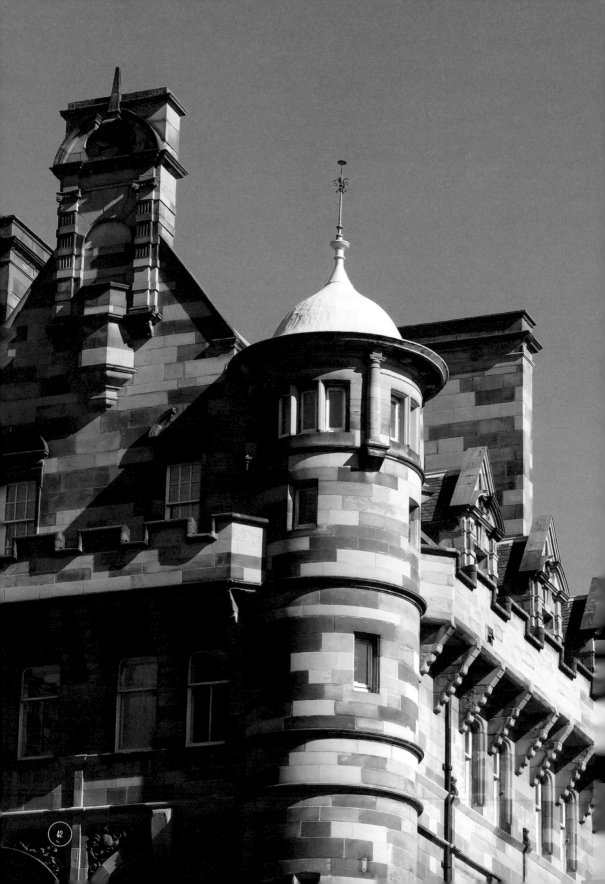

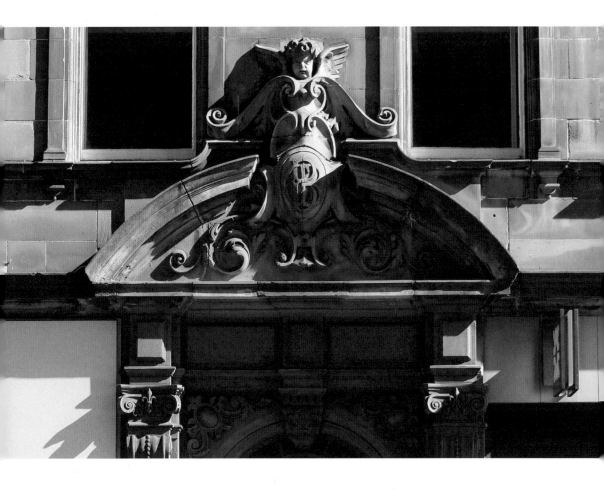

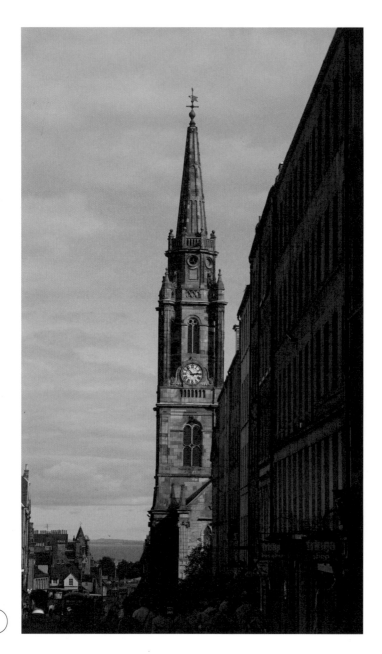

43

44

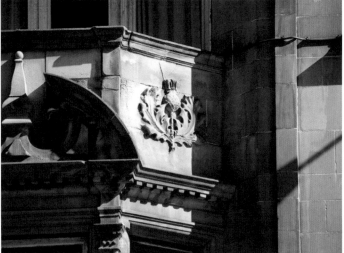

44

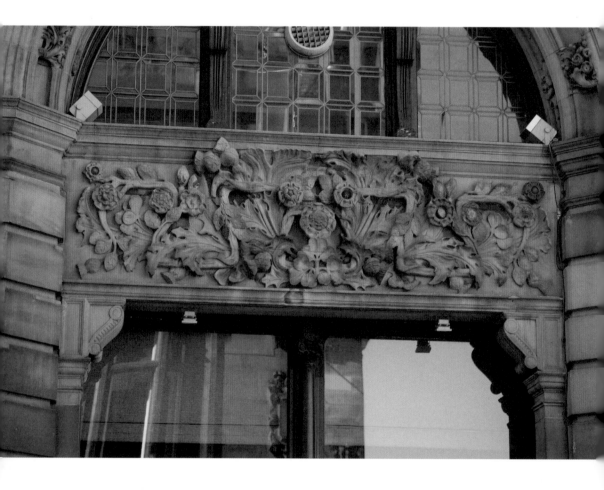

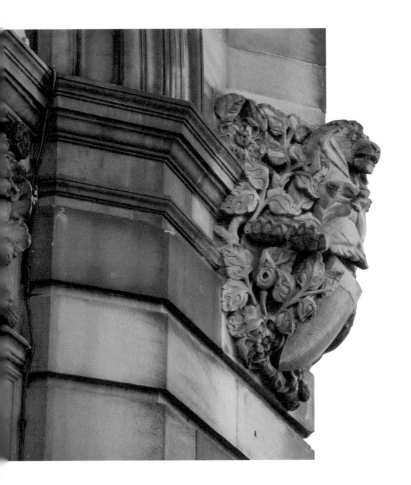

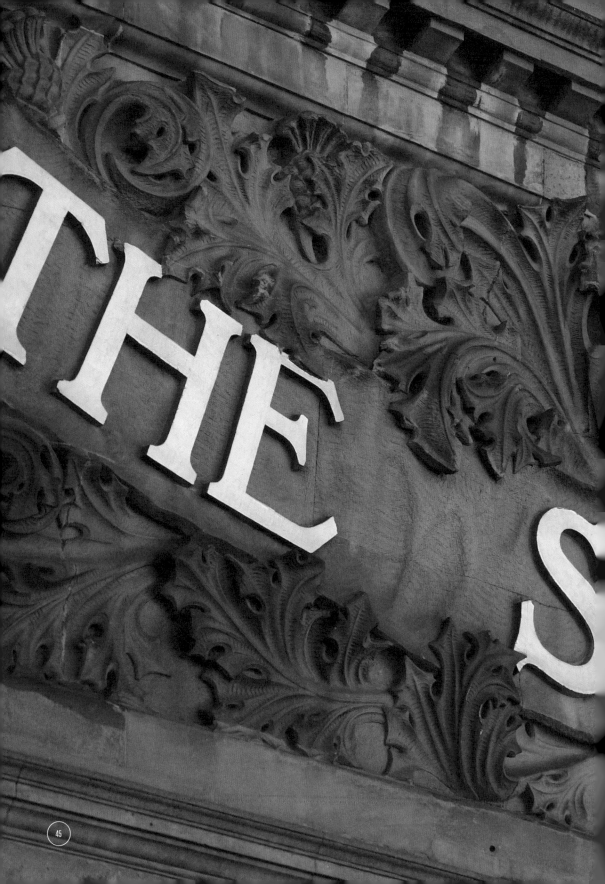

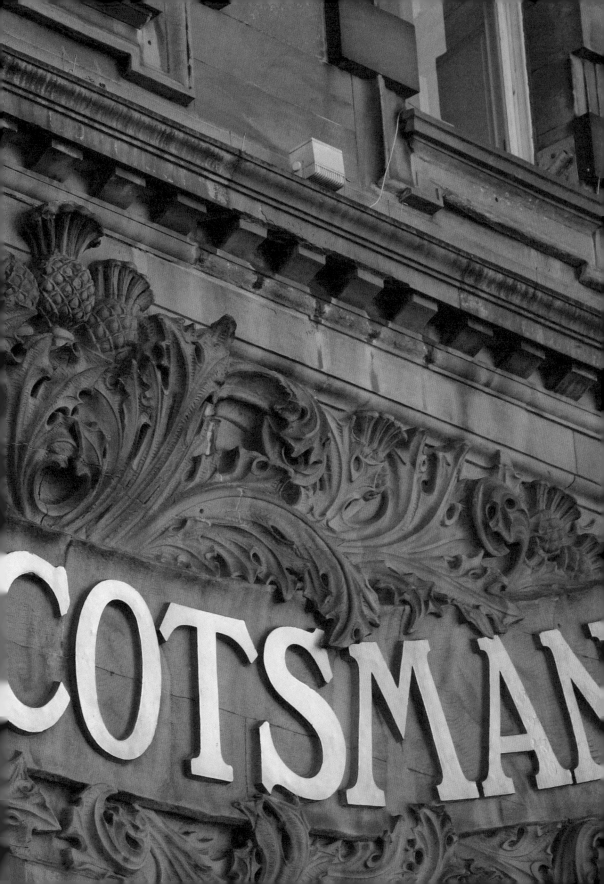

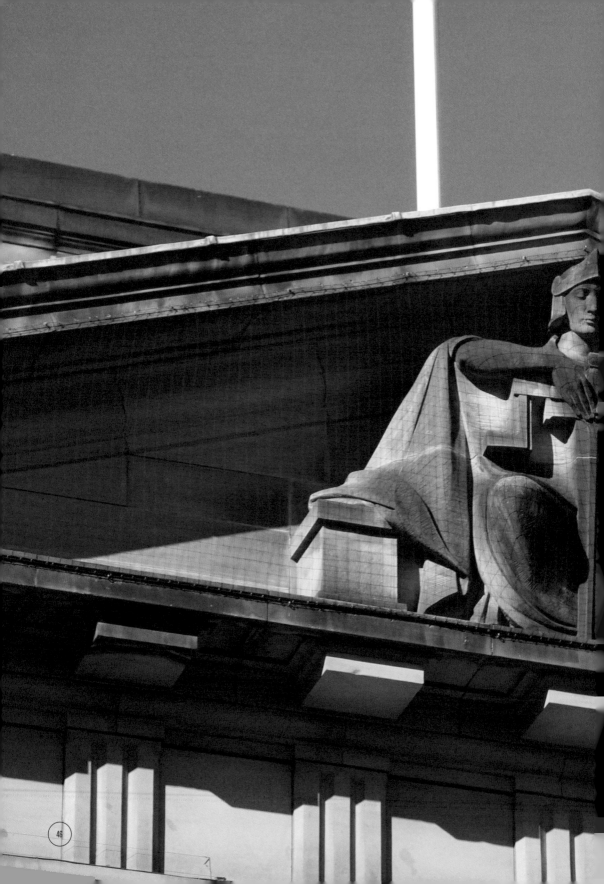

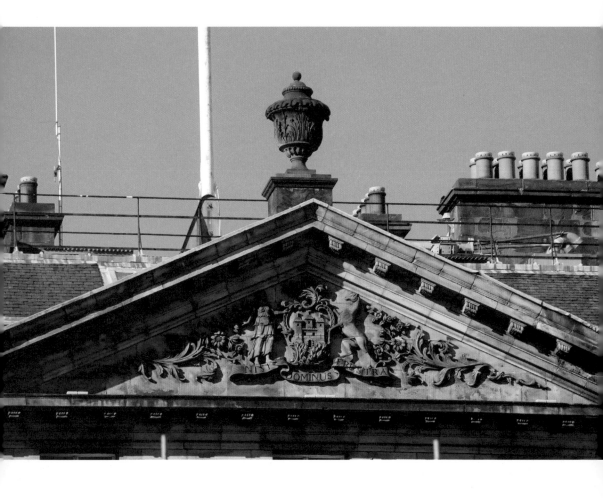

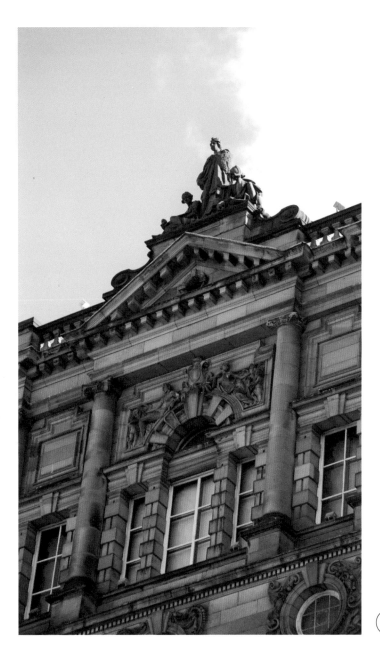

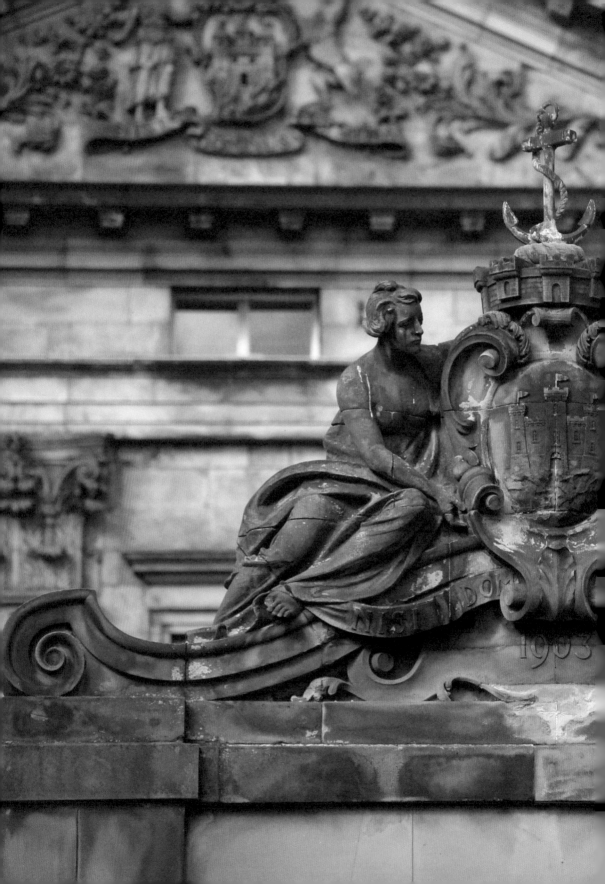

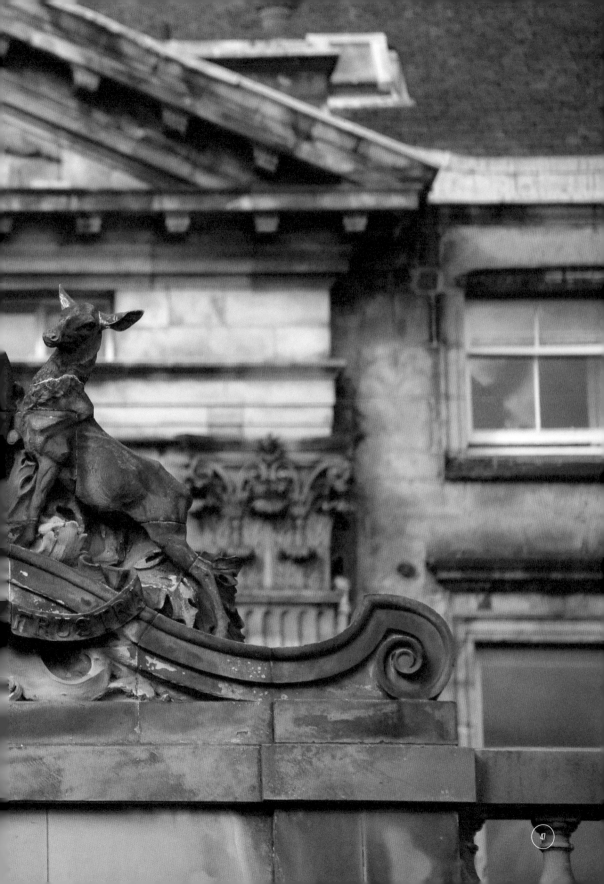

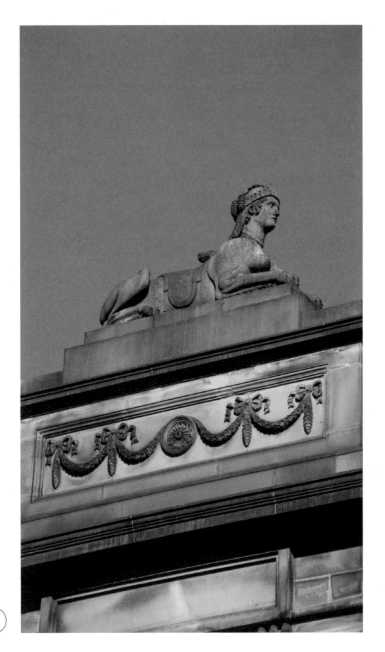

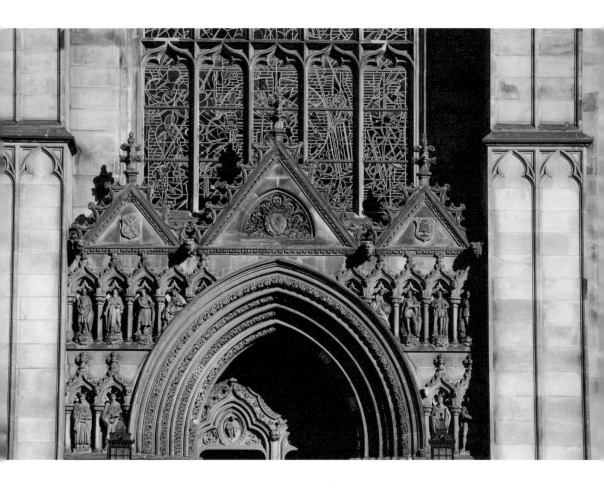

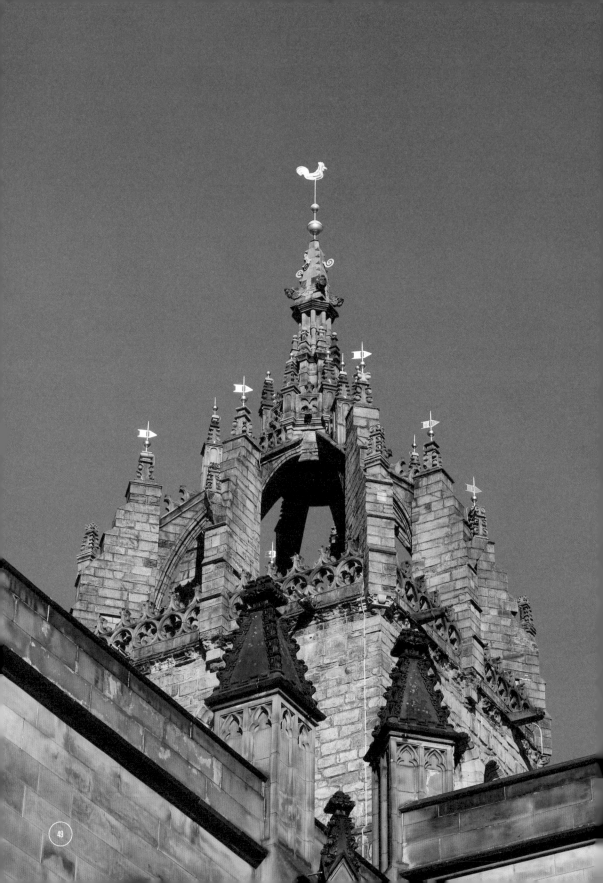

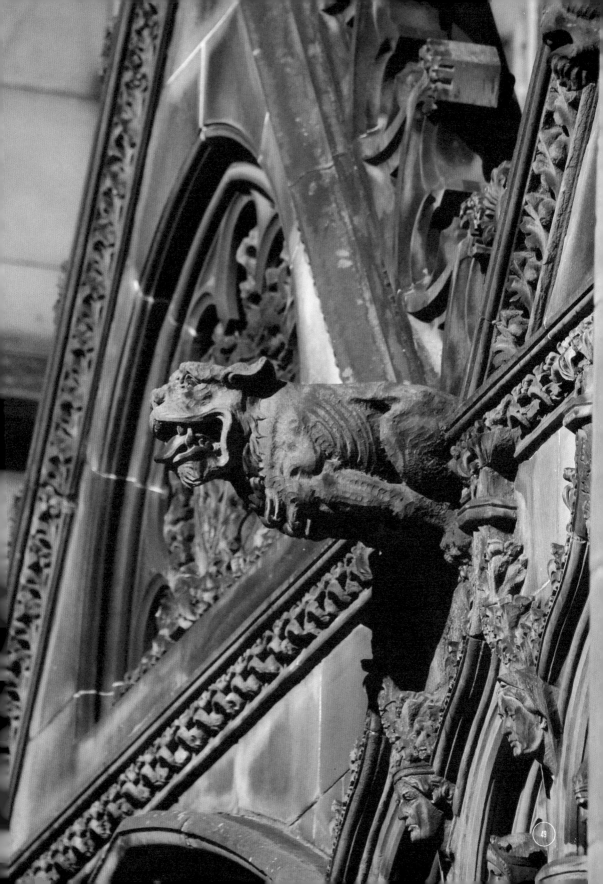

S E

FAMILIÆ NAPER.

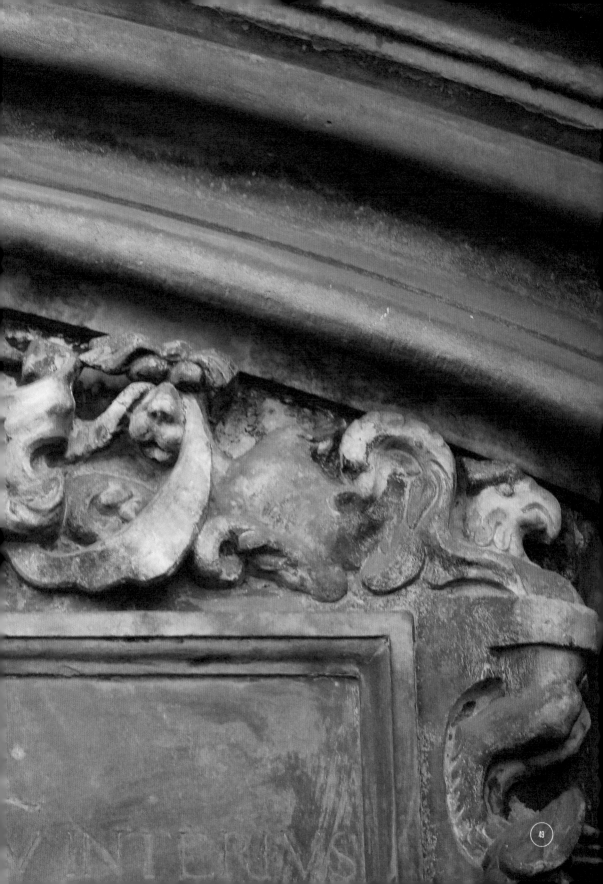

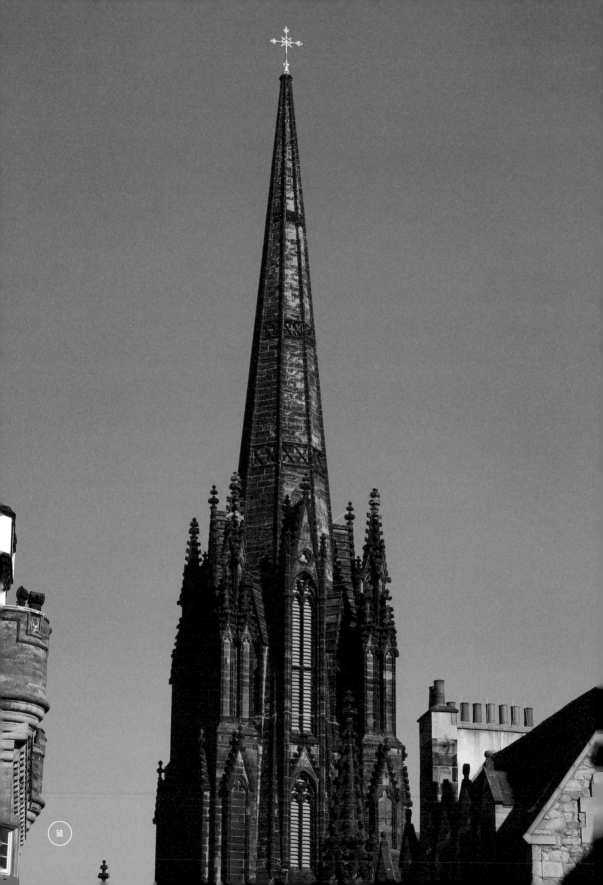

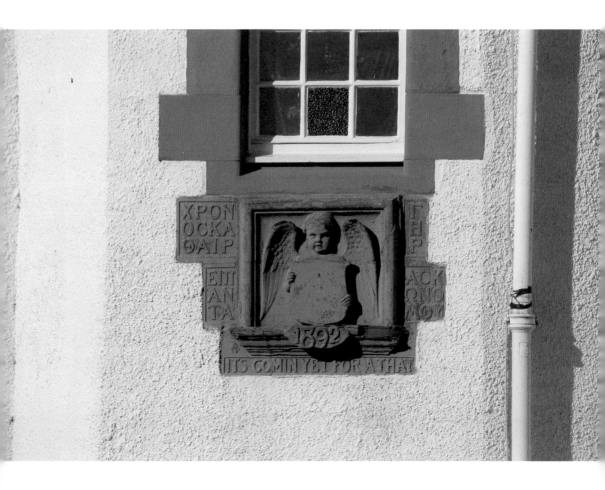

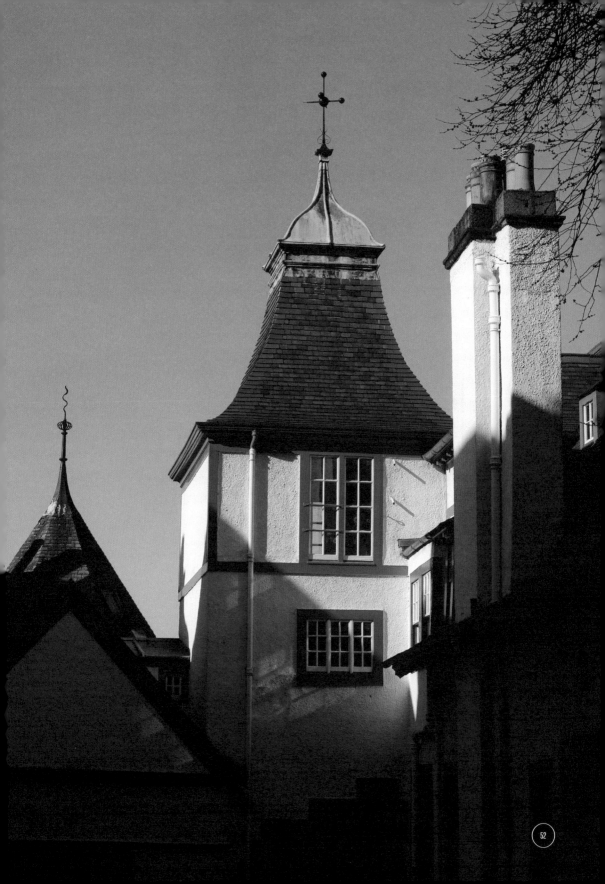

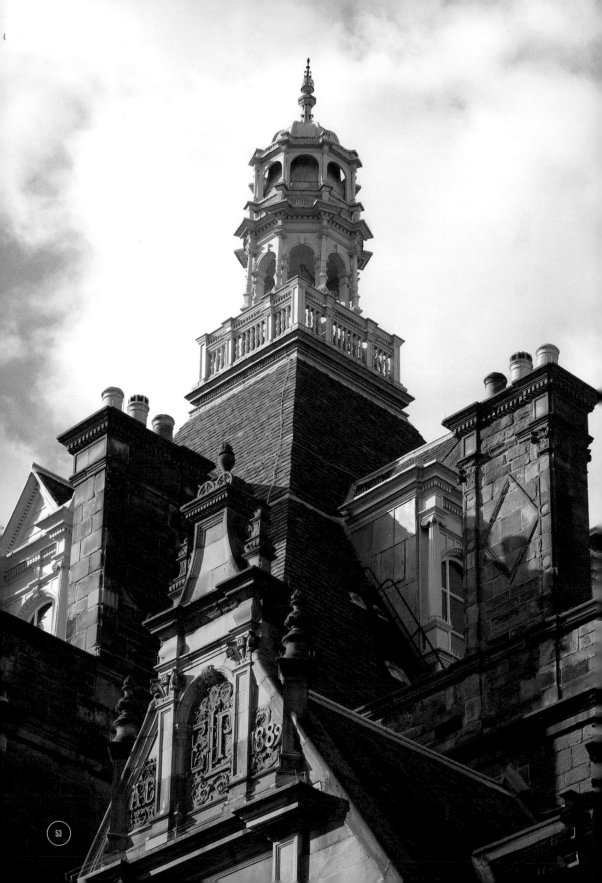

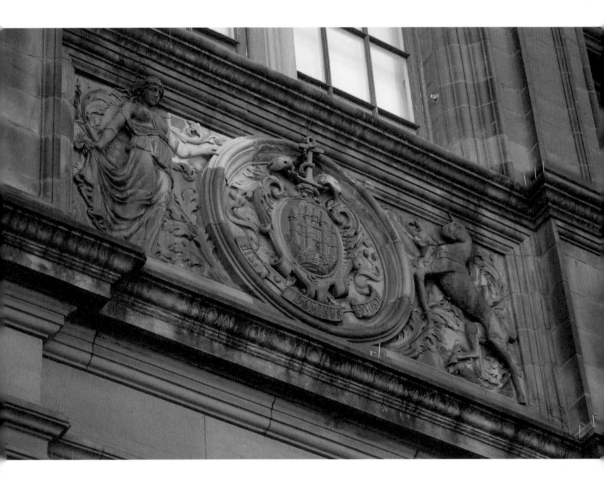

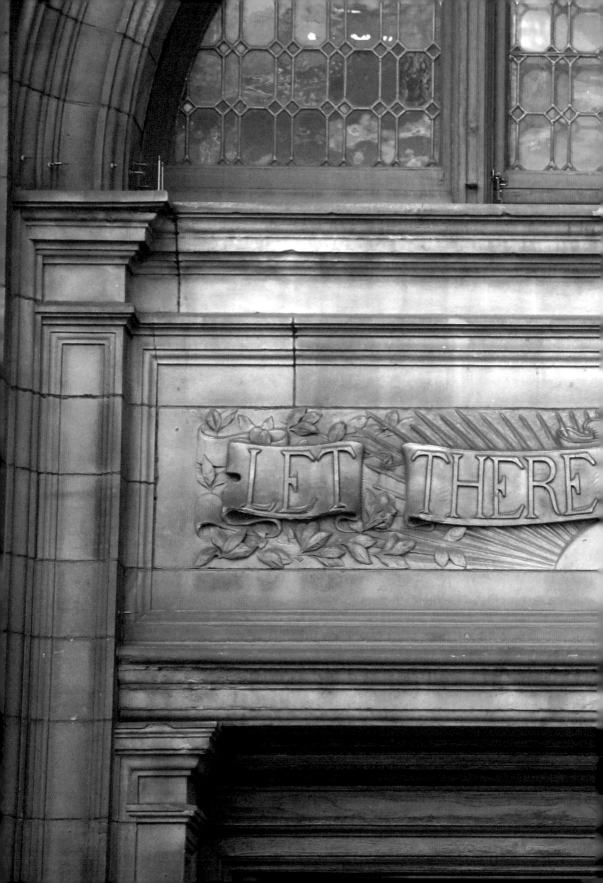

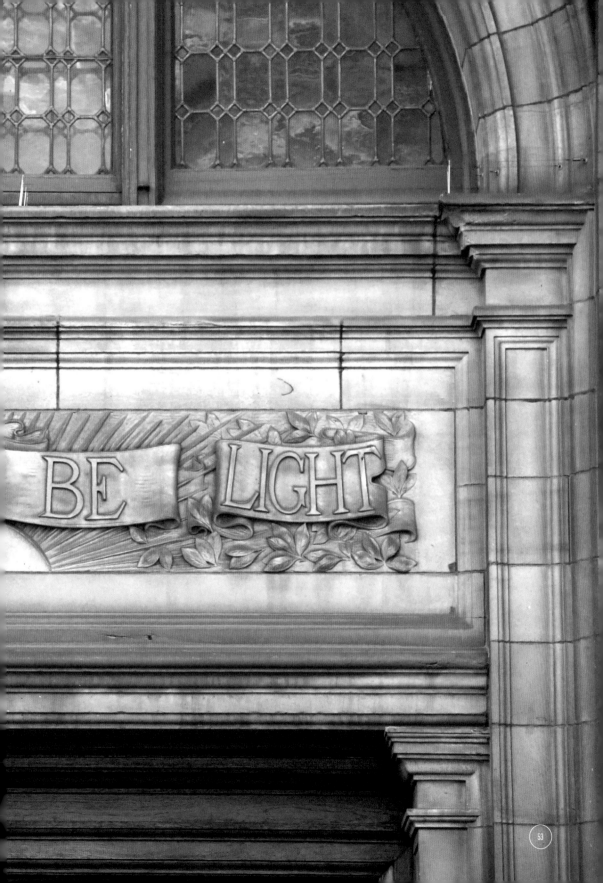

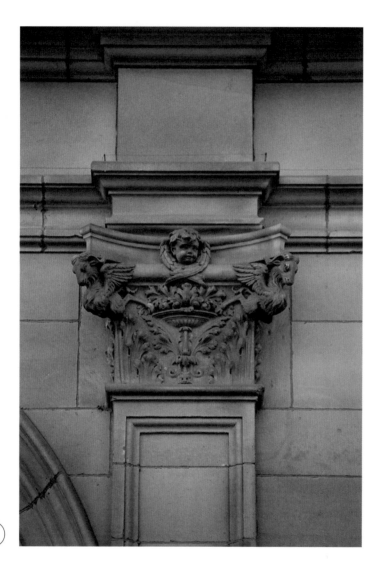

53

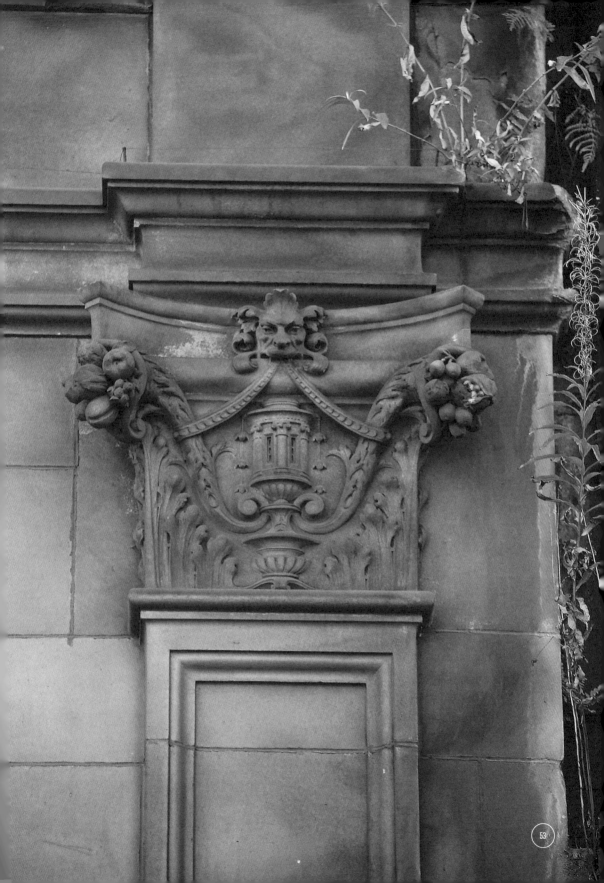

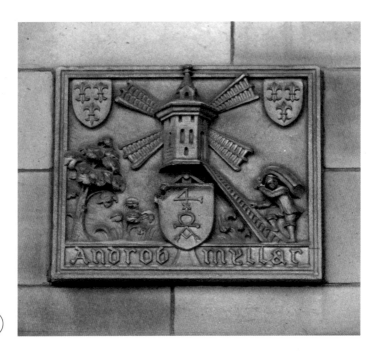

53

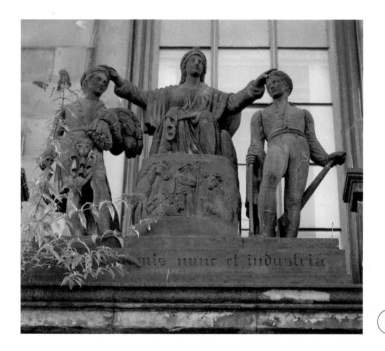

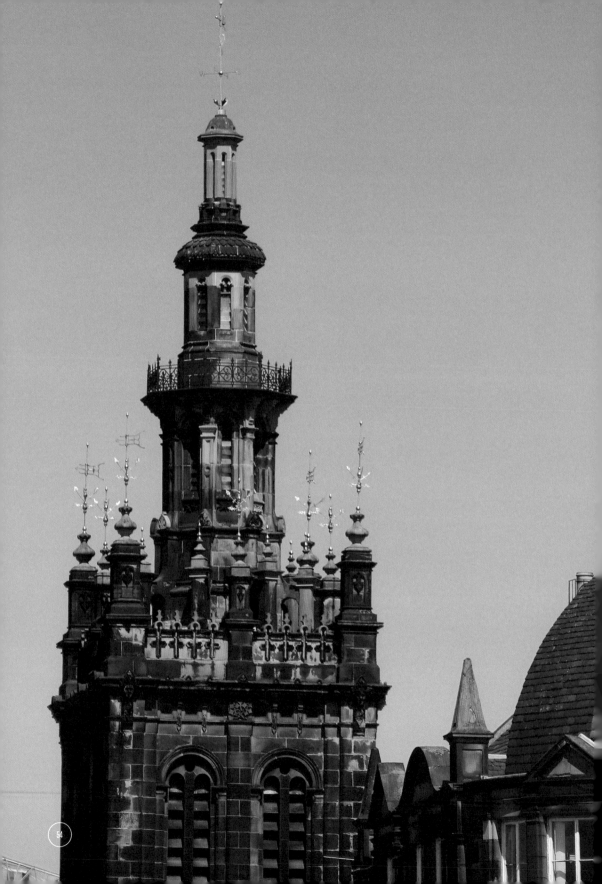

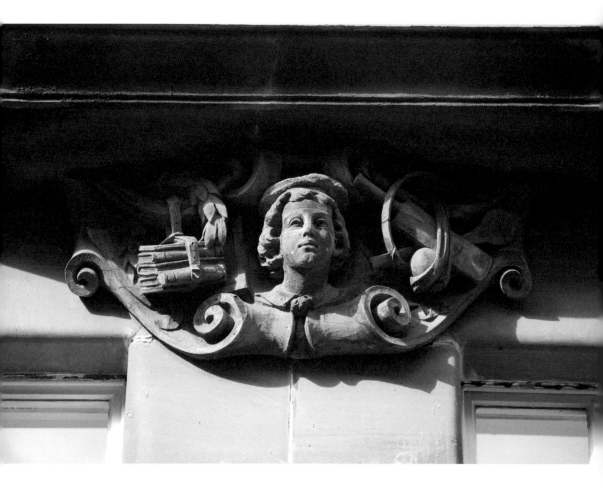

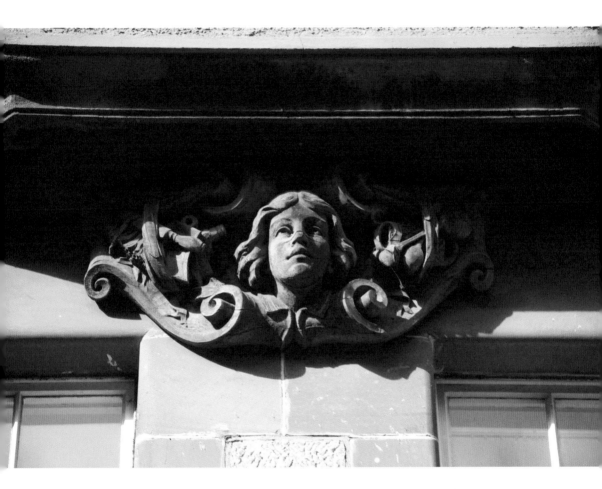

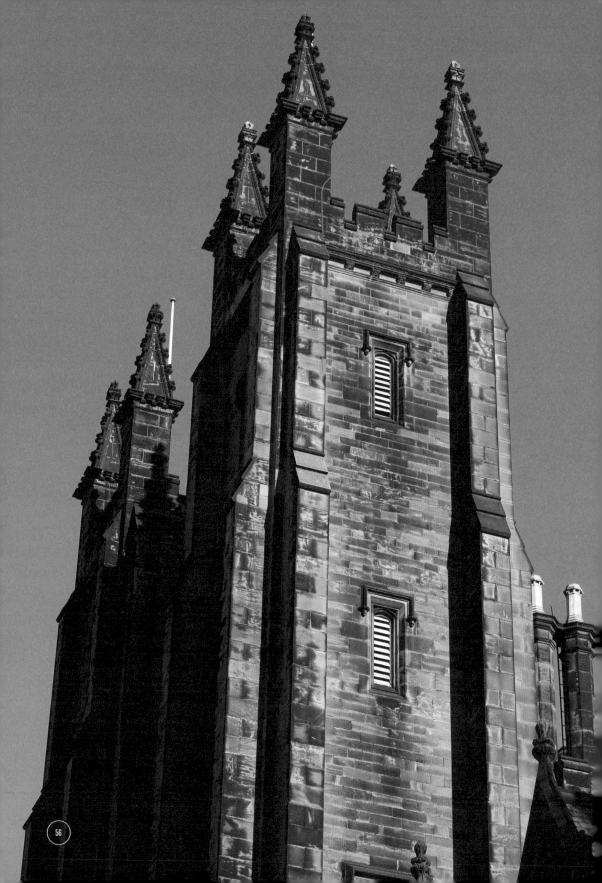

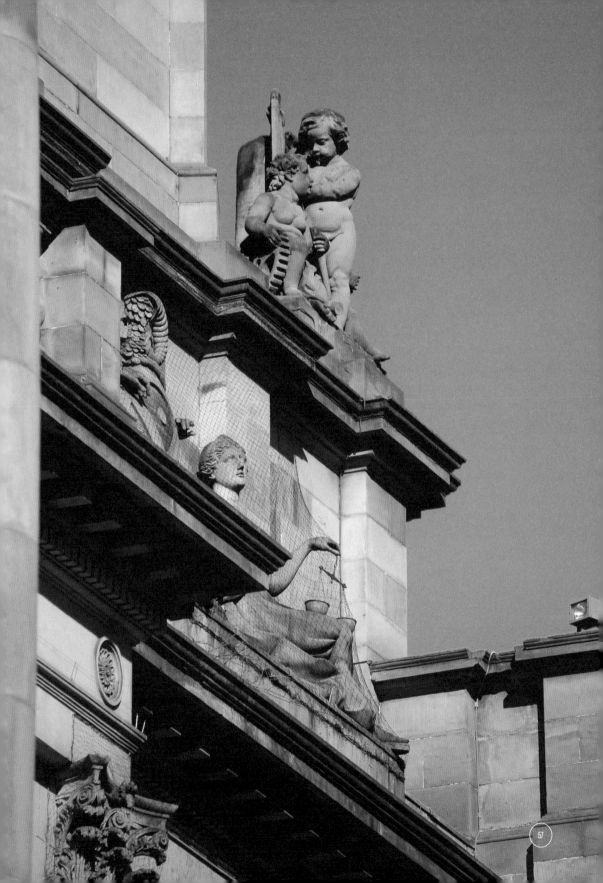

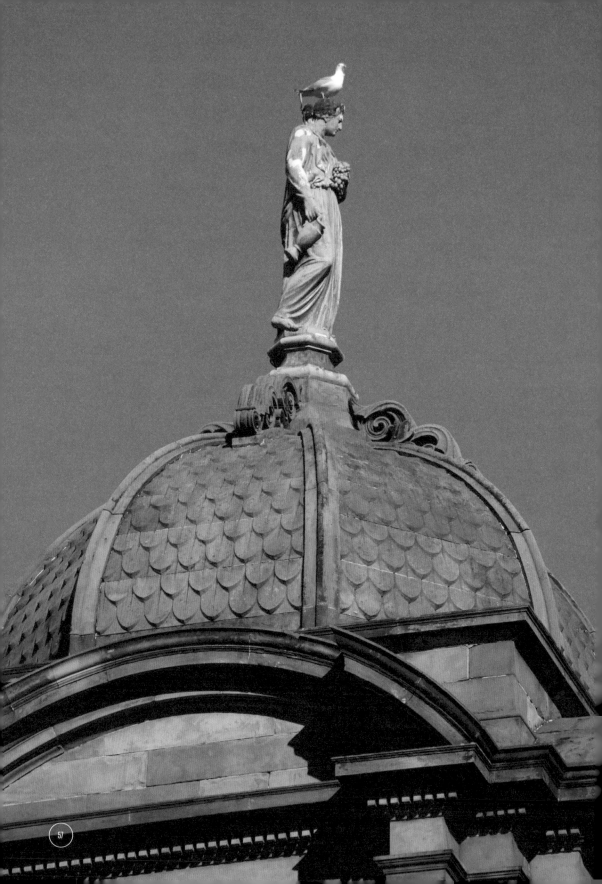

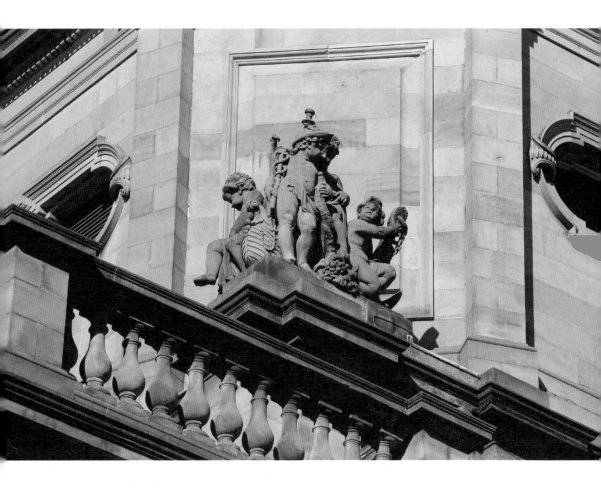

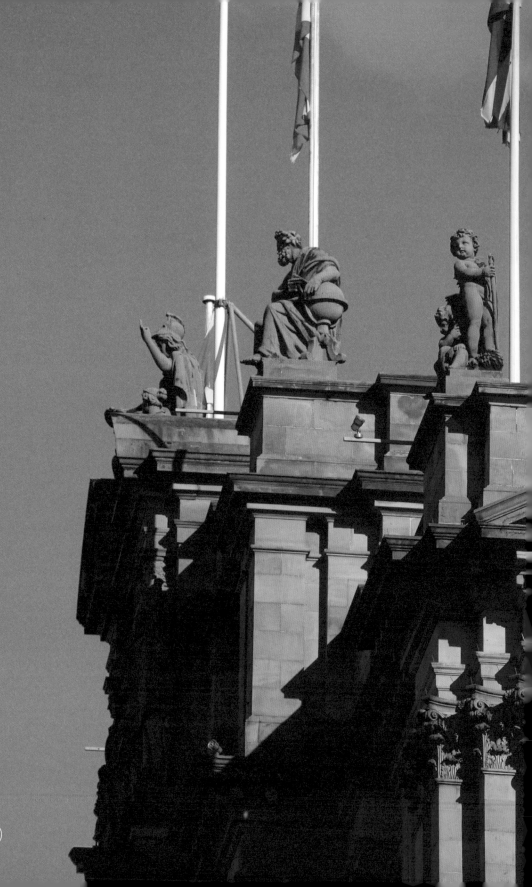

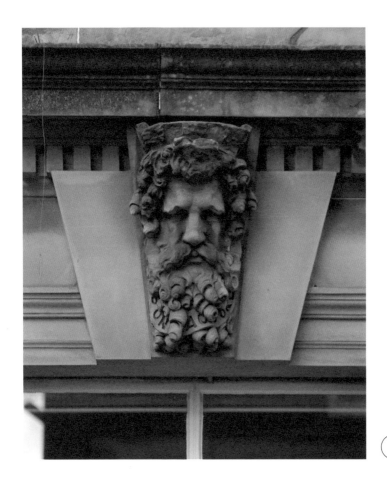

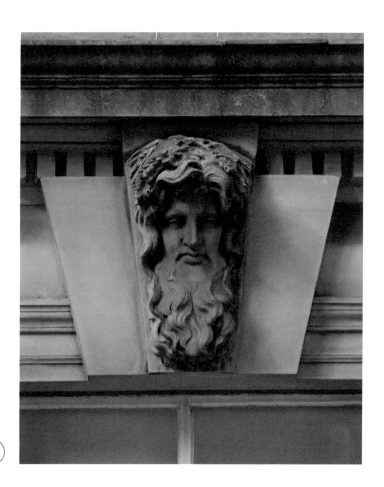

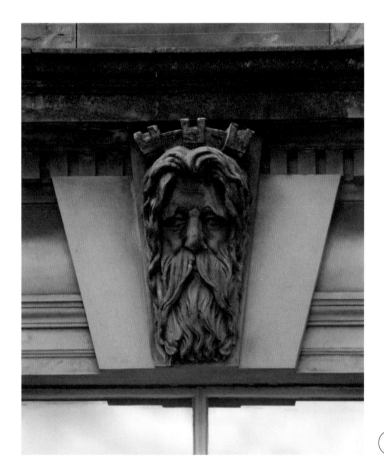

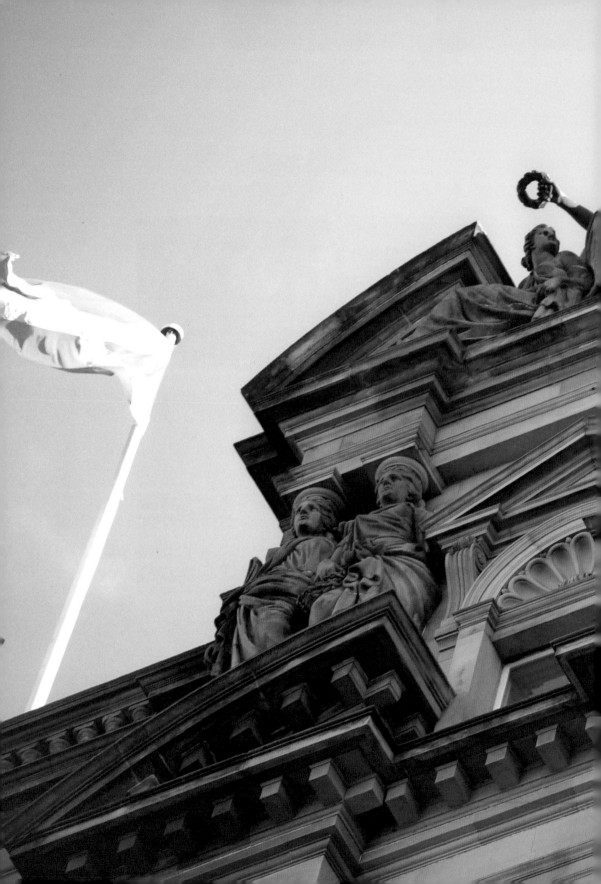

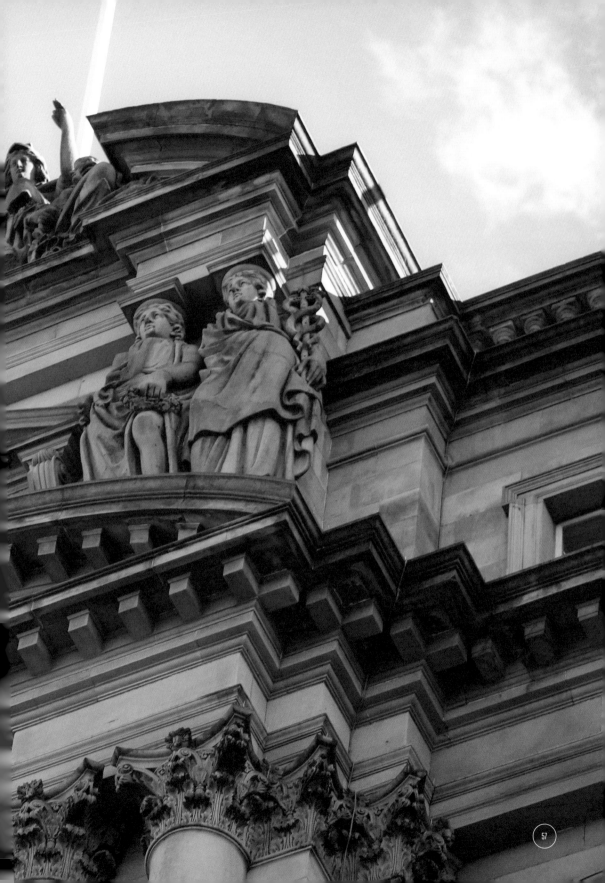

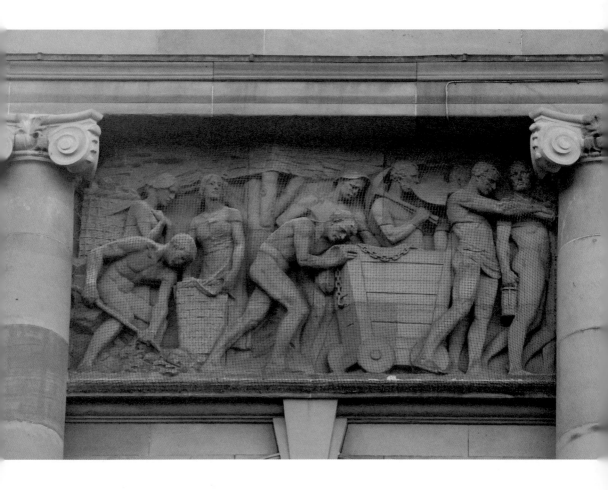

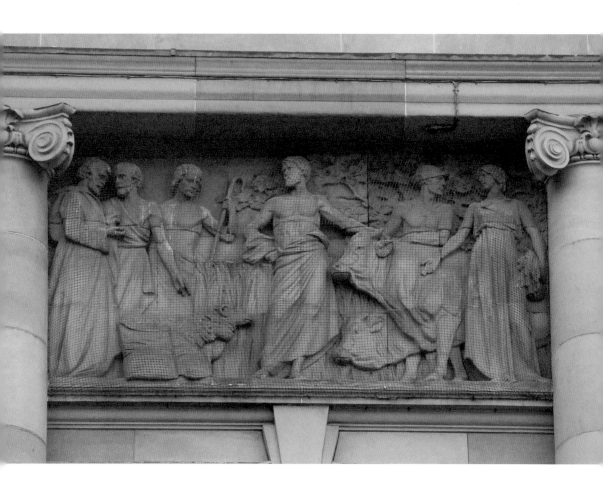

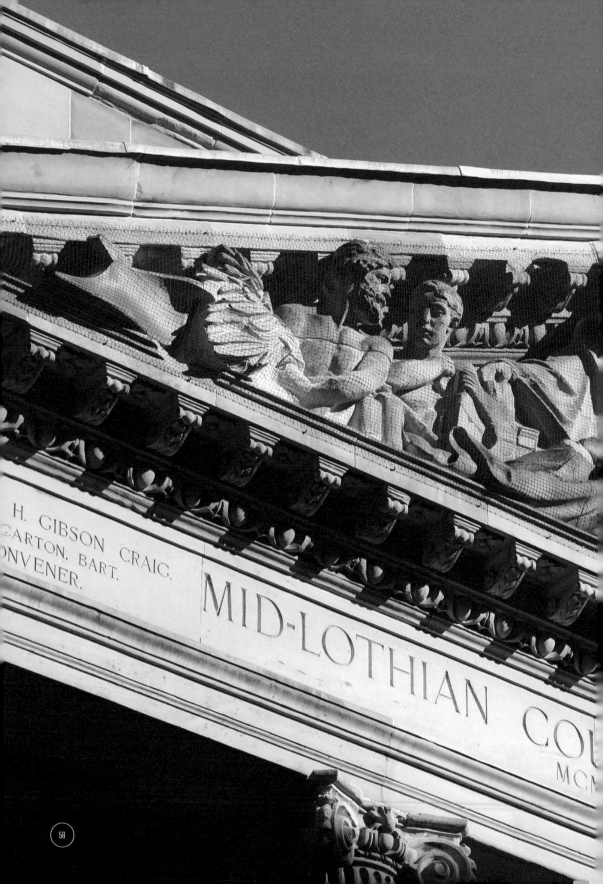

H. GIBSON CRAIG.
CARTON, BART.
ONVENER.

MID-LOTHIAN COU

MCM

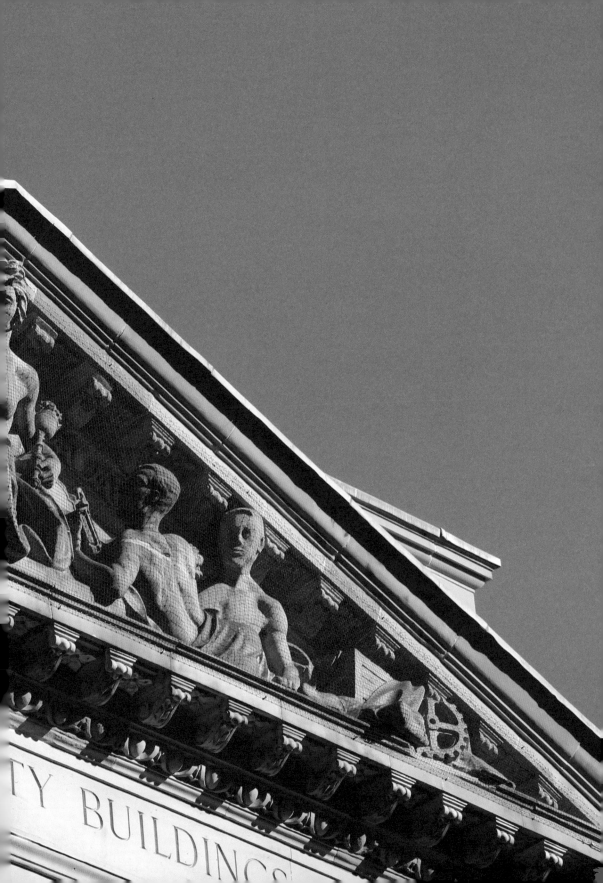

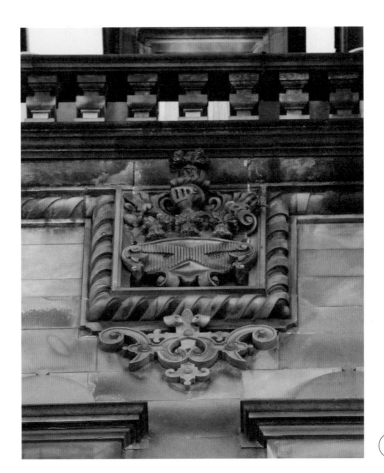

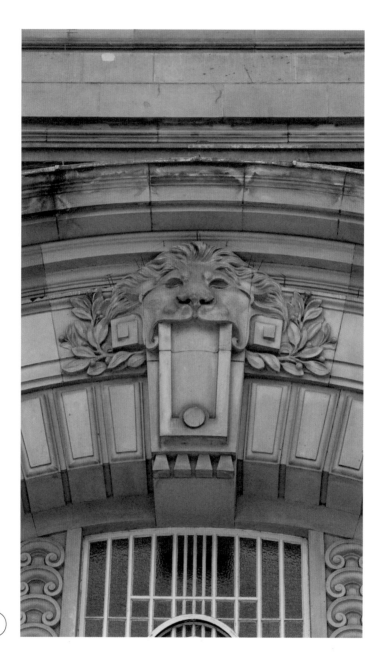

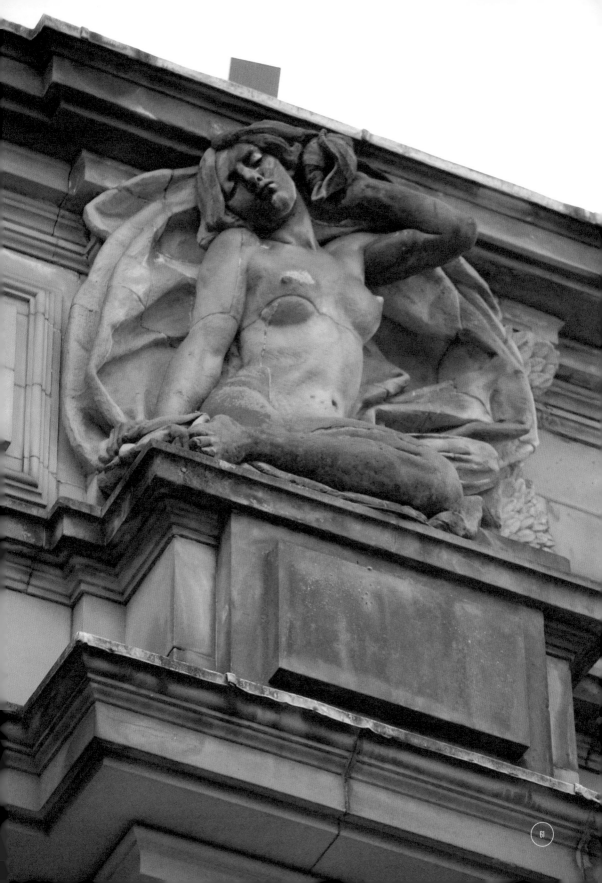

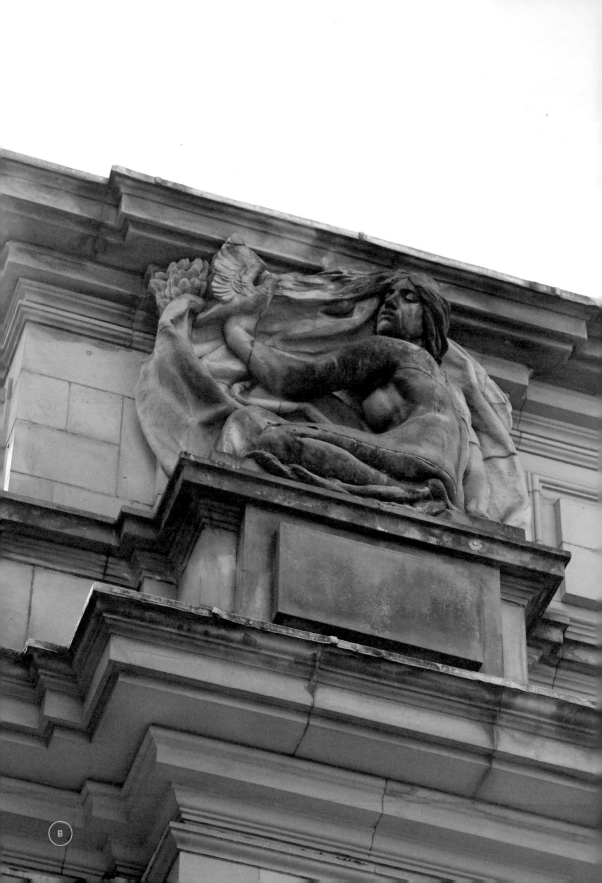

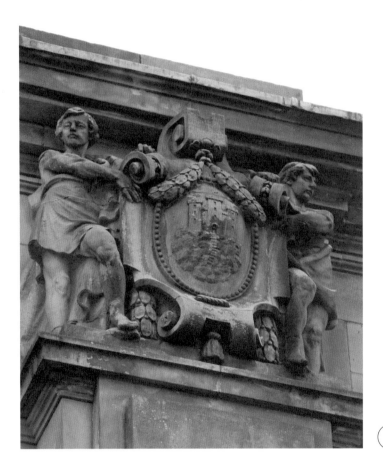

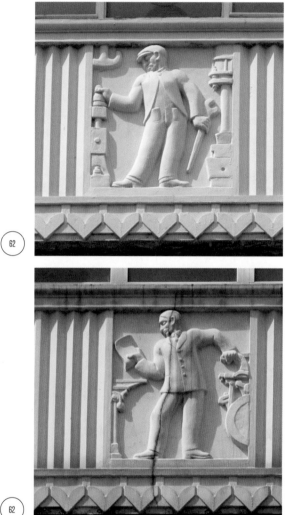

62

62

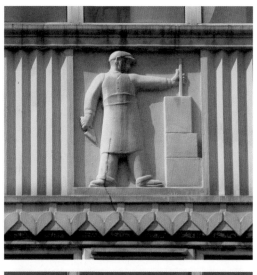

62

62

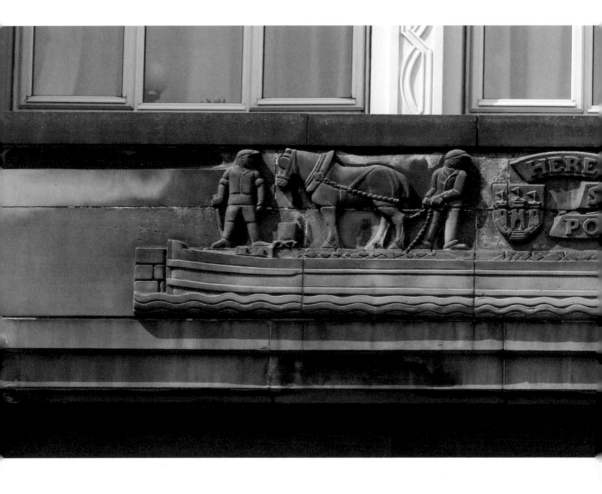

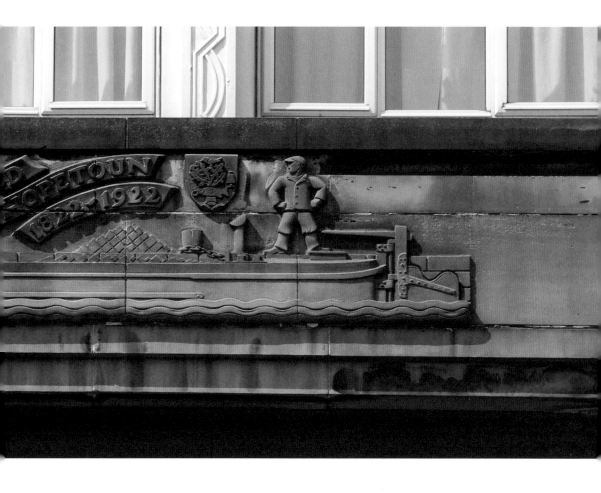

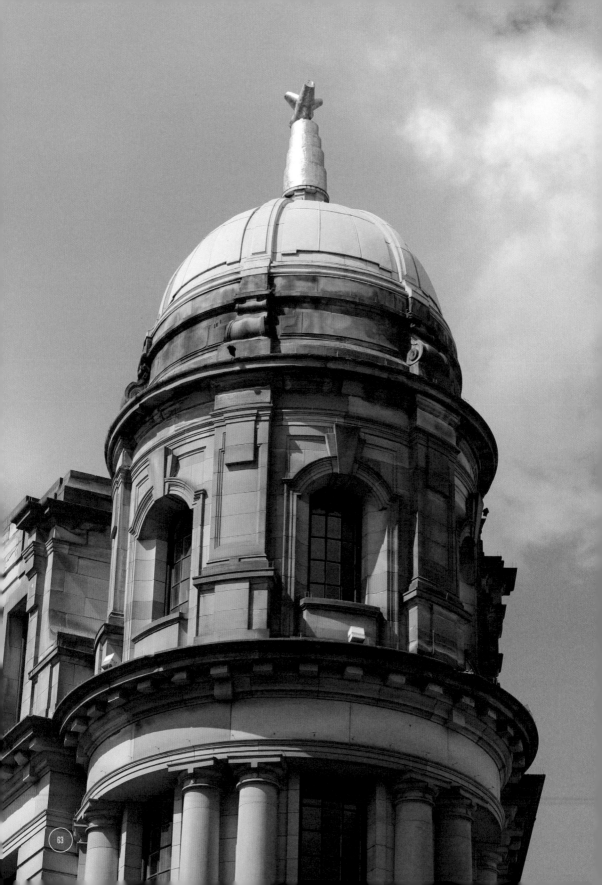

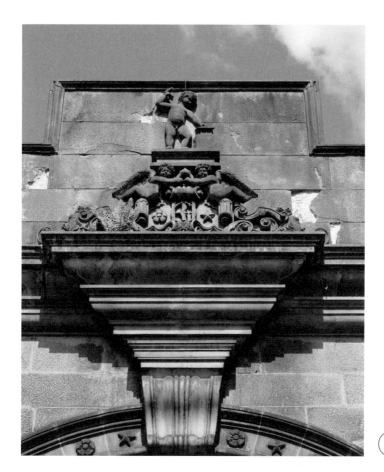

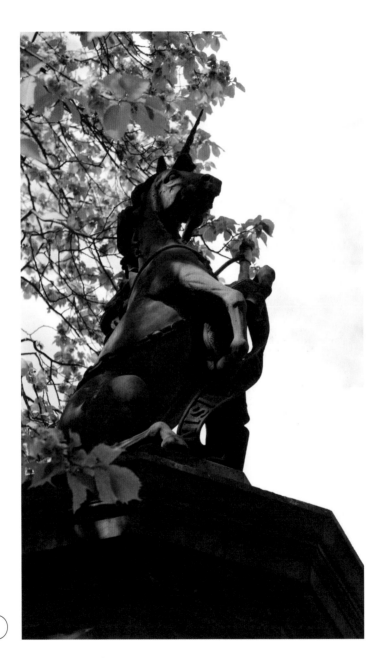

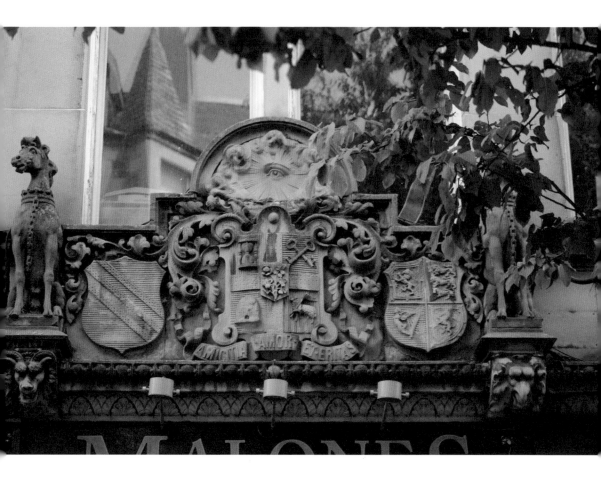

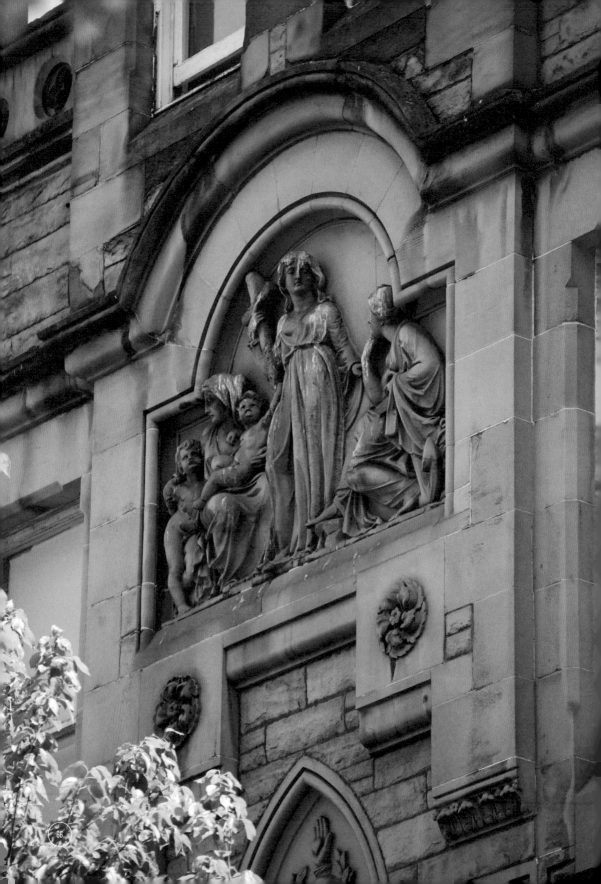

Malones

Theresa Muñoz

Sometimes in this oak and brick bar
I find myself in a group of men,
conscious of their shaving lotion and over-bright ties,
just listening as they chat about women
in a half-complaining way,
their speeches punctuated by
back slaps, table knocks, gulps
from a swirled pint
until feeling a kind of panic in the chest,
they utter so-longs and rush out
into the tapping rain
unaware of the female stone figures
etched into the studded rockface
above their heads, arms forgiving
knowing how late home they'll be.

66

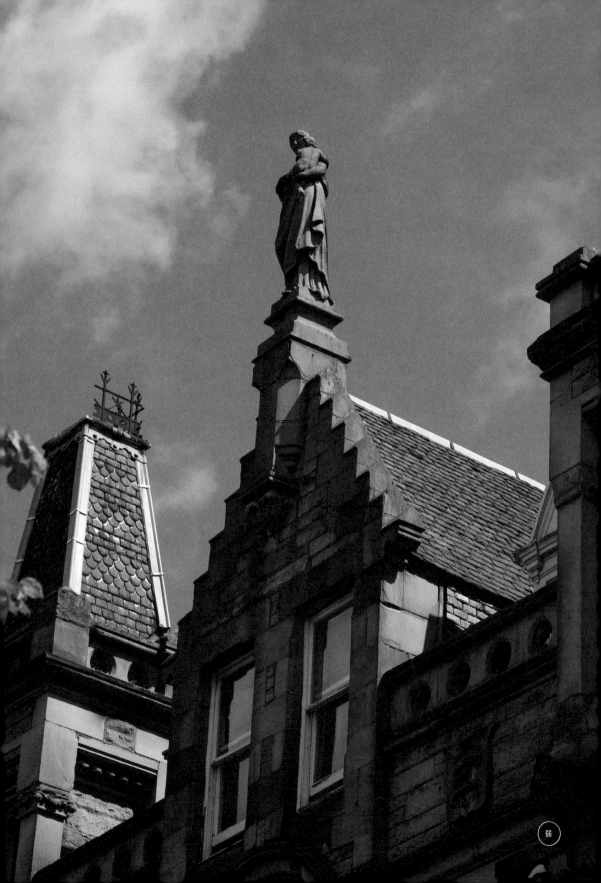

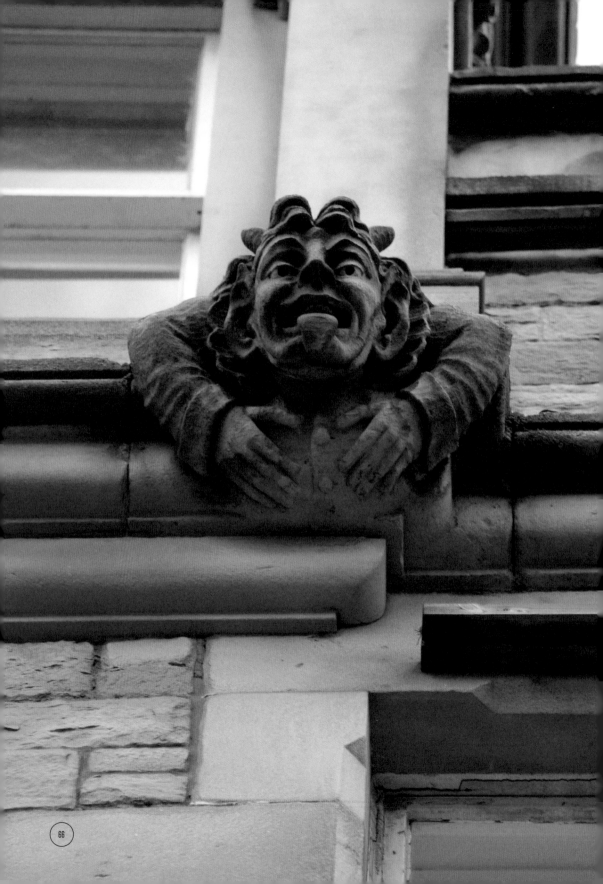

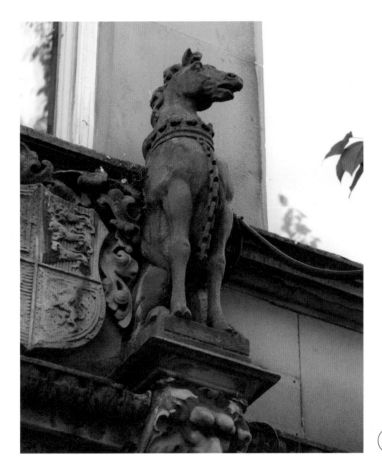

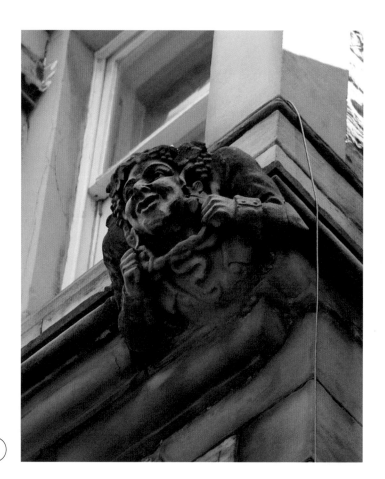

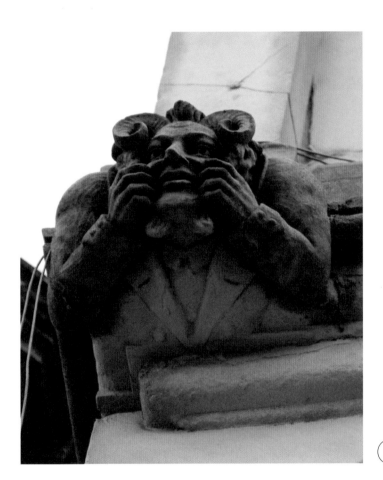

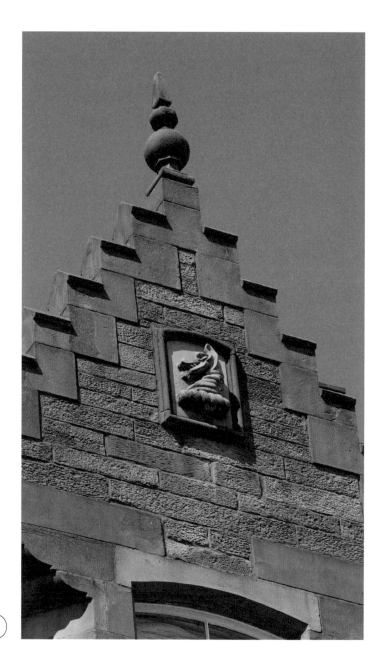

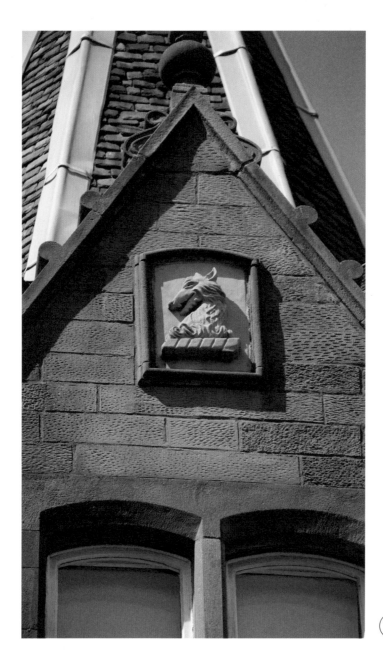

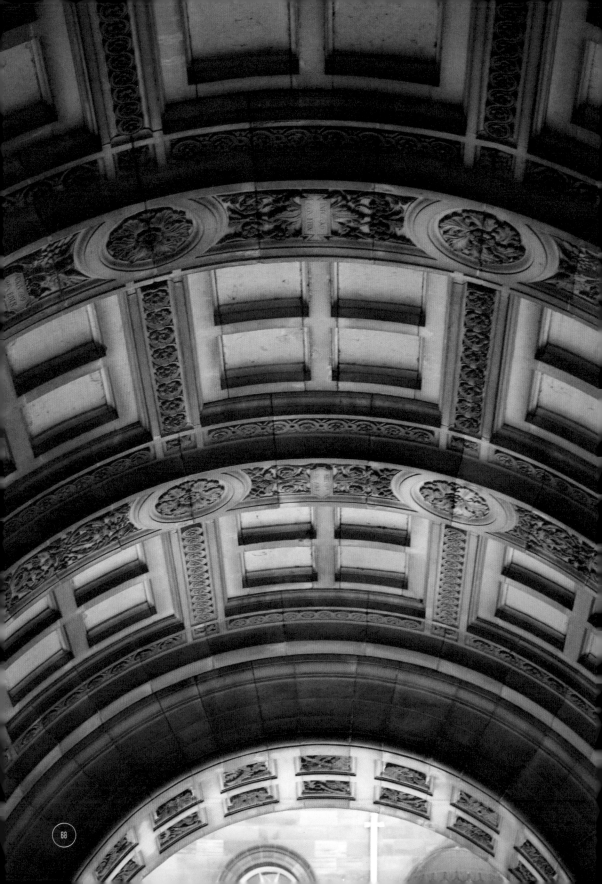

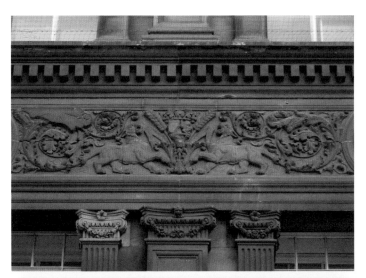

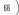

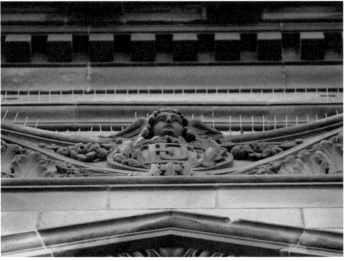

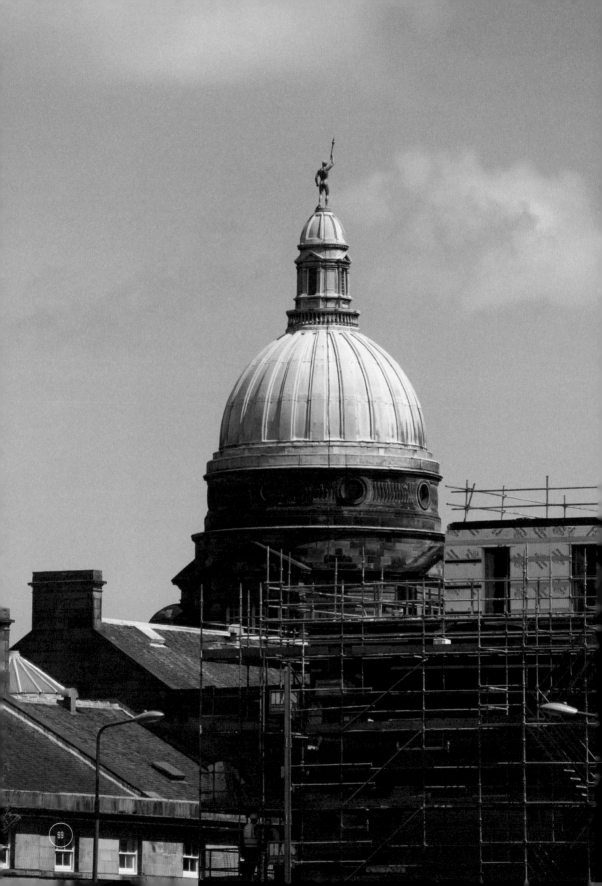

Ad Summum

Jane Bonnyman

From cold benches,
shadowed lawns,
we pick you out,
golden Olympian,
lustrous icon.

Perhaps those before us
imbibing law, philosophy,
looked up to catch you
one foot arching, ready
to race across the sky.

If only we could follow,
skim over rooftops,
domes, spires -
our tracks behind us,
in wisps over blue,

but our ascent is slow:
one morning a steel frame,
the next – tarpaulin,
timber boards, handrails,
a bridging ledger.

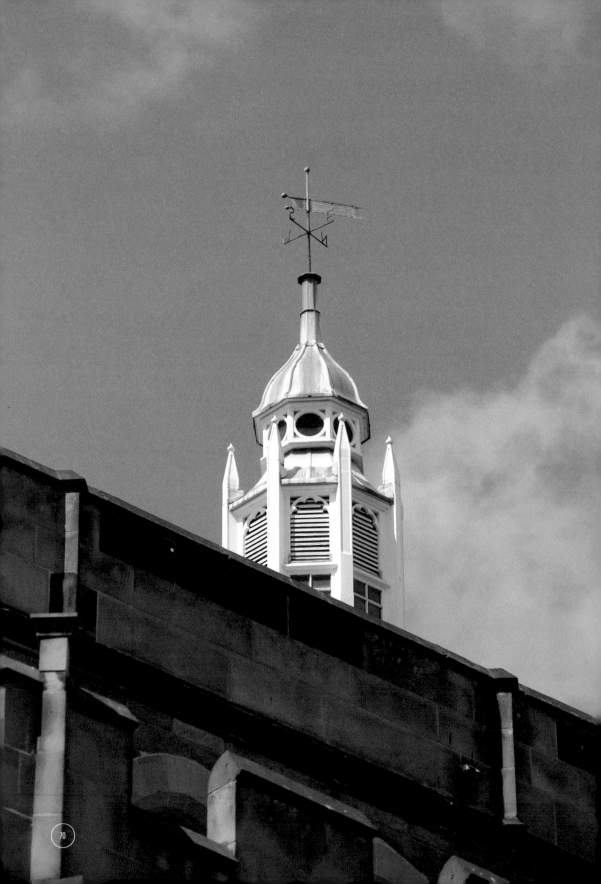

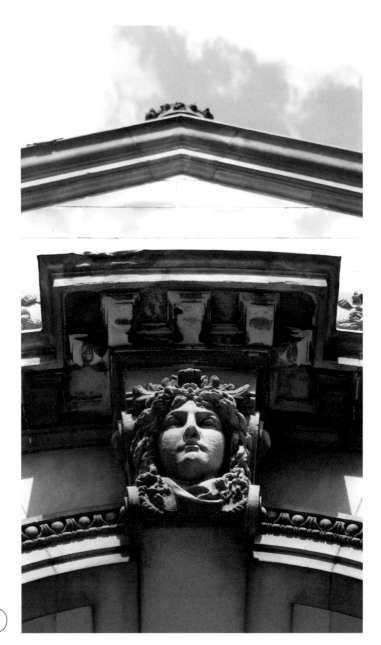

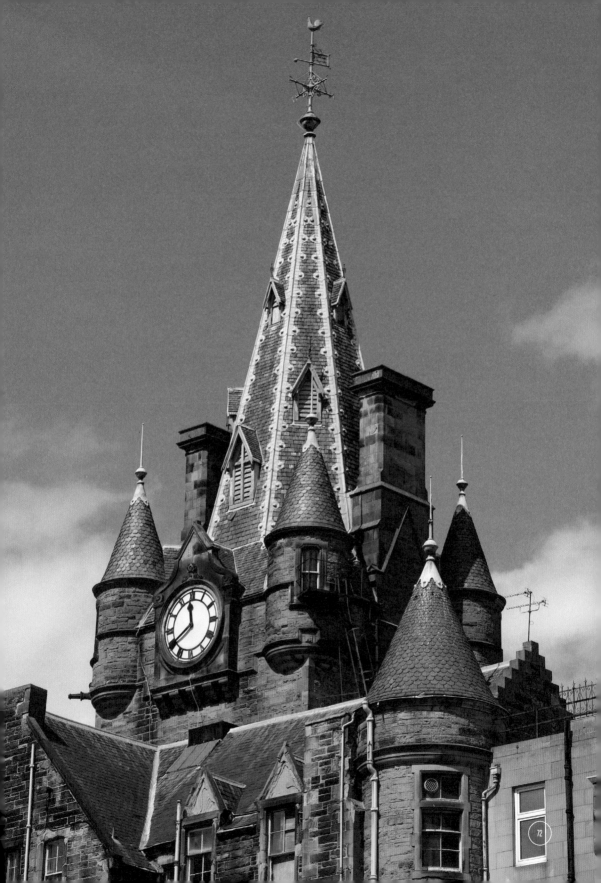

72

REFERENCE

40. 47-53 Cockburn Street
Architects: Peddie & Kinnear (1859-61)

Cockburn Street was formed to link up the Old and New Towns and provide a more direct route to Waverley Station. The commissioning company was imaginatively called the Edinburgh High Street & Railway Access Company. Formerly the Adelphi Hotel, numbers 47-53 are more elaborately detailed than the others on the street, which was restored in 1978-81 by the City Architect's Department. I lived at no 46 for several years in the early 1990s in a top floor flat. I loved nothing better than climbing onto the flat roof, high above the street, and looking across the majestic Edinburgh skyline, past the North British Hotel, as it was then, to the River Forth in the distance.

41. Royal Mile Mansions, 50 North Bridge
Architect: Dunn and Findlay (1899-1902)

Above the North Bridge arcade is an allegorical figure by W Birnie Rhind while on the High street façade two putti survey the thousands of wannabe thespians who gather every August.

42. Former Royal Bank of Scotland, 29-31 North Bridge
Architect: Sydney, Mitchell & Wilson (1898)

A building in the mixed Renaissance style with an elegant corner turret, commissioned by the Commercial Bank of Scotland. Details include a fabulous winged cherub's head on top of decorative scrollwork above an open curved pediment.

There are strong similarities between this and the former National Bank of Scotland (also most recently RBS) building on the corner of Glassford Street and Trongate, Glasgow, although the latter was built 4 years later by the architects Thomas P Marwick. Shamrocks and thistles add a playful touch to the façade of the Edinburgh version.

43. Tron Church, High Street
Architect: John Mylne (1637-47)

The Church was founded to house the congregation displaced when St Giles became a cathedral. Hence the inscription above the door in the centre, which reads 'The Temple of Christ and church owed to the citizens of Edinburgh in 1641.' The original wooden steeple was destroyed in the great fire of 1824, which decimated everything from the Kirk up to Parliament Square. An eyewitness described the steeple burning like a 'beautiful firework.'

44. Carlton Highland Hotel, 3-27 North Bridge
Architect: William Hamilton Beattie (1898)

Together with the Scotsman building, the Carlton Highland Hotel forms an ornate gateway to the Old Town. The high turrets of both signify the transition between the classical New and the exotic old.

45. Scotsman Building, North Bridge
Architect: Dunn and Findlay (1899-1902)

This stunning English Baroque building stands guard at the entrance to Edinburgh's Old Town. Many know and love the huge carving of the Scotsman newspaper's masthead, on the North Bridge façade. However many of the city's inhabitants are unaware of the great sculptures on the north side overlooking Princes Street. Atlas figures, an allegorical representation of Peace by Frederick EE Schenck, figures of Mercury and Night and Day (sadly armless these days) by Joseph Hayes, reclining on pediments, all add up to a lavish programme far more reminiscent of the commercial buildings of Glasgow.

46. High Court, Lawnmarket
Architect: AJ Pitcher and J Wilson Paterson, HM Office of Works (1934-7)

Sculptor: Alexander Carrick

A rather grim figure of Justice in the pediment about the entrance to the High Court stands watch on all those unfortunate to find themselves paying it a visit.

47. Edinburgh City Chambers, High Street

Architect: John Fergus after designs by John Adam (1761)

Initially combining the City Chambers, a customs office, coffee houses, shops and flats, by 1893 the City Council had occupied the entire building. The south-facing sculptured coat of arms and screen on the High Street was added in 1901. At the rear, from Cockburn Street, a group of three figures is visible at the very top of the building. Queen Victoria, carrying a shield with the Edinburgh arms, is flanked by two allegorical female figures. Two women recline atop the arched window below.

48. Parliament Square, High Street

Architect: Robert Reid (1803-38)

Influenced by an earlier scheme by Robert Adam, Parliament Square hides the hotchpotch of buildings behind, including Parliament House, built between 1632 and 1640, the Court of Session, the High Court, Advocates', Signet and Solicitors' Libraries.

49. St Giles Cathedral, High Street

(12th century with amendments till 19th century)

The first church on this site dates back to around 1130 although much was built between the 14th and 16th centuries. The famous tower and crown were added just before 1500. The ornate West doorway, facing onto Parliament Square, was completed in 1884 and is by architect William Hay with sculpture by John Rhind. The flying gargoyles are somewhat reminiscent of Paisley Abbey's recent Alien and Predator replacements.

50. The Hub, formerly St John's Parish Church, Castlehill

Architect: James Gillespie Graham, with Augustus Webly Pugin (1841-44)

At 240 feet high, the former St John's Parish Church is the tallest spire in Edinburgh, and to my eyes looks more like an intercontinental ballistic missile than a steeple.

51. Camera Obscura, 543-549 Castlehill

Architect: David Rhind (attr.) (c17th Century, additions 1853)

The lower four floors of Edinburgh's Camera Obscura, original built as Short's Observatory, date back to the mid-17th century, possible as the mansion of the Ramsays of Dalhousie. The Observatory was remodeled by social reformer, town planner and all-round good egg Patrick Geddes in 1892 and renamed the Outlook Tower. In additional to the original camera obscura, Geddes also included his Civic Survey of Edinburgh exhibition.

52. Ramsay Garden, Castlehill

Architect: S Henbest Capper, Sydney Mitchell (1892)

Ramsay Garden was the eccentric vision of social reformer and town planner Professor Patrick Geddes as a mixed-use complex of student accommodation and proto-social housing – and is now one of the city's most desirable addresses. Incorporating Allan Ramsay's self-designed Ramsay Lodge from 1740, it's a mix of Scots Baronial and the English Cottage style so loved by the Arts and Crafts movement. Inside, individual interiors were decorated by Celtic Renaissance painters, Phoebe Traquair and John Duncan.

53. Edinburgh Central Library, George IV Bridge

Architect: G Washington Brown (1887-90)

French in style, the Central Library is actually built up from the Cowgate, four stories below the main entrance. The east façade, facing the street, is decorated with a wide range of fascinating carving and decoration. Above the Edinburgh Central Children's Library at 3 George IV Bridge are figures of Agriculture, one a ploughman, the other kilted and carrying a sheath of corn. Both are being blessed by an allegorical figure probably representing Bounty. Somewhat ironically, the weeds growing from the stonework are bountiful.

54. Augustine Bristo Congregational Church, 41-43 George IV Bridge
Architect: J, WH and JM Hay (1857-61)

This Romanesque church has what critics have described as a 'frivolous' tower. I have always liked it.

55. Wardrop's Court, 453-461 Lawnmarket
Architect: S Henbest Capper (1892)

Another social housing project by Professor Patrick Geddes, this is a late Victorian evocation of the building's 18th century predecessor. Sculpted emblems of arts, sciences and crafts sit under the protruding upper floors (or oriels).

56. New College, University of Edinburgh, The Mound
Architect: William H Playfair (1845-50)

Built as a church and theological college for the Free Church of Scotland, New College is now the home for the University of Edinburgh's School of Divinity, one of the UK's leading centres for the study of Theology and Religion. The building also includes the Church of Scotland's Assembly Hall at the rear, Rainey Hall, a gothic revival dining hall, and the New College Library.

57. Bank of Scotland, The Mound
Architect: Richard Crichton, David Bryce (additions) (1806)

The original 1806 building was not admired and David Bryce was hired to make substantial additions, including much of the sculpture. Allegorical figures representing Prosperity, Plenty and Fame gaze down from the façade, while other statues representing Britannia and her children, Agriculture, Navigation, Commerce and Mechanics can also be seen. Such figures were common for banking buildings, and represented the hopes and aspirations of the company. I once appeared on the front cover of the Bank of Scotland annual report, photographed scowling as I emerged from the front doors of the building. Wrong place, wrong time.

58. Lothian Chambers, 59-63 George IV Bridge
Architect: J MacIntyre Henry (1900-05)

The Midlothian County Buildings were completed in October 1904 and cost £40,000. A competition was used to commission the the east-facing frieze on the Parliament Square façade. In three panels, it depicts indigenous industry. The left panel representing Mining contains figures shoveling and mining coal. The middle panel depicts a more rural scene symbolising Agriculture, while the right panel shows Fishing, as seen in the figures holding baskets of fish. On the west-facing pediment, there is a large high-relief carving of a group of four reclining male figures with a central semi-draped female holding a torch in her left hand and a book in her right. In the left corner is a ploughshare and a large wheatsheaf; in the right corner is a cog and a crate. Several of the figures have suffered major erosion.

59. 1 Upper Bow
Architect: J Russell Walker (1884-6)

The houses on Upper or West Bow contained some famous residents, including the 'evil Major Weir' who was executed for witchcraft in 1670. After his death the house was left empty for 200 years as people were said to be too afraid to live in or even enter it. This doorway features a delicate piece of detail. A Gothic Revival arch includes a carved thistle.

60. India Buildings, 1-2 Victoria Street
Architect: David Cousin (1864)

Above the entrance you can see a sculpted female keystone with a wreath of corn in her hair, flanked by two lion masks. David Cousin was not the original designer and made great alterations and amendments to the original plans.

61. Usher Hall, Lothian Road

Architect: Stockdale Harrison (1910)

As befits a concert hall, the two female figures that can be seen on either side of the arched window symbolize the Soul of Music and Musical Beneficence. The former holds a lyre and rests her hand on a pile of books, while in a meta twist the latter holds a model of the Usher Hall itself.

62. Lothian House,
122-144 Lothian Road

Architect: Stewart Kaye

Sculptor: Pilkington Jackson (1935-6)

An Art-Deco version of Kodak House in London, the building is decorated with panels depicting four trees and four trades used in different combinations. The trees represent the four seasons, while the four workers, unlike the nursery rhyme are a builder, a brewer, a printer and a mill-worker.

63. Doubletree Hotel, 34 Bread Street

Architect: TW Marwick

Sculptor: unknown (1937)

Formerly housing the St Cuthbert's Co-Operative Association. A sculpture depicting flying fish rises from the dome, although some have described it as looking more like a 'dumpy airplane'.

64. George Heriot's School Gatehouse,
Lauriston Place

Architect: William H Playfair (1829)

Founded by the Royal Goldsmith and philanthropist George Heriot. His portrait can be seen above the entrance wearing a rather fetching ruff. Above him is the Heriot Coat of Arms, a shield decorated with three roses, a helmet and a cornucopia of fruit and crops. The Gatehouse mimics the Jacobean style of the main building, with pepperpot turrets and flanking lodges.

65. Meadow Walk Unicorns.
Middle Meadow Walk

Architect: Handyside Ritchie (1850)

Two unicorns flank the entrance to the Meadows, each holding a staff and flag. The flag on the right contains the Lion rampant, the Scottish Royal Banner of Arms. The unicorn on the left is sadly missing its flag. Bloody students.

66. 14 Forrest Road (Malone's Irish Bar)

Architect: JC Hay (1872-3)

Originally formed for the 'Oddfellows', the name given to any broad group of tradesmen or lodges. Three allegorical female figures representing Faith, Hope and Charity can be seen above the entrance this former Masonic Hall, while a number of grotesque gargoyles mock those paying £5 a pint in the pub below.

67. 15-23 Forrest Road

(1872)

Although perhaps not as enjoyable as Oddfellows Hall, this tenement building is decorated with framed panels depicting three animal heads; a wolf, a horse and a lion.

68. University of Edinburgh Medical School, Teviot Place

Designer: Robert Rowand Anderson (1876-86)

The original plans for the McEwan Hall and Medical School complex were considered to be too extravagant for the Government, who refused to fund the project. Brewing magnate William McEwan eventually stepped in. The Medical School is in a Venetian Cinquecento style with a fabulous vaulted archway entrance.

69. University of Edinburgh,
Old College, Nicholson Street

Architect: Robert Adam (1789)

Sculptor: John Hutchison

In 1785, it was agreed that a 'New College' should be built, as the Old College of the university was considered to be decrepit. Robert Adam's original plans were considered too grandiose and rejected, but Adam successfully sued the City for his fees and later acquired the job with a new brief.

The 'Golden Boy' atop the Old College dome is 6ft high and was added in 1888. He holds the torch of knowledge in his right hand and a recent refurbishment

required 100 books of 23.5-carat gold leaf to recover the statue.

70. University of Edinburgh, Teviot Row Union, Bristo Square
Architect: Sydney Mitchell and Wilson (1887-8)

The oldest purpose-built Student Union in the world, the building has undergone various additions over the years and has presumably been the site of many drunken events. It is in the 16th century Scots baronial style with crow-stepped gables and drum towers. Previously, the site was occupied by a more wholesome maternity hospital.

71. Former George Watsons Ladies College, now University of Edinburgh Dept of Psychology, 7 George Square
Architect: MacGibbon & Ross (1876-93)

The original George Watsons Ladies College was opened in 1871, following the decision to create a school for girls. The school's coat of arms decorates the building and depicts a shield flanked by two horse-sea serpent hybrids. The shield contains traditional representations of Edinburgh and Scotland including a three towered castle and a thistle and saltire.

72. Former Royal Infirmary, Lauriston Place
Architect: David Bryce (1872-79)

Established in 1729, the Royal Infirmary is the oldest voluntary hospital in Scotland and had previously been located, unsurprisingly, on Infirmary Street. The building on Lauriston Place had previously housed George Watson's College, who were asked to move to make way for the hospital. The new building was built around William Adam's original and Florence Nightingale gave her personal approval to the designs.

POETS

Jane Bonnyman

Jane is a Clydebuilt 7 poetry mentee and has previously
been published in *Gutter, New Writing Scotland* and *Poetry
Scotland*. She lives in Edinburgh.

Ron Butlin

With an international reputation as a prize-winning novelist,
Ron Butlin is also a former Edinburgh Makar / Poet
Laureate. His work has been translated into over a dozen
languages. His most recent novel is *Ghost Moon* (SALT
Publishing, 2014), and his collection of poetry, *The Magicians
of Edinburgh* (Polygon, 2012) is now in its sixth printing.
2015 will see the publication of his new collection *Scotland's
Magic* (Polygon), and his first book of poetry for children,
Here Come the Trolls! (Polygon).

Anna Crowe

Poet and translator of Catalan and Mexican poetry, she is
co-founder and former Artistic Director of StAnza,
Scotland's International Poetry Festival. Her Mariscat
collection, *Figure in a Landscape*, won the Callum Macdonald
Memorial Award and was a Poetry Book Society Choice.
Her latest book of translations, *Peatlands* (Arc 2014), features
the work of the Mexican poet, Pedro Serrano. In 2005 the
Society of Authors awarded her a Travelling Scholarship.
Her poetry has been translated into Catalan, Spanish, Italian
and German.

Theresa Muñoz

Theresa was born in Vancouver, Canada and lives in
Edinburgh where she works as a tutor and researcher. She
has been shortlisted for the Melita Hume Poetry Award and
has been a prizewinner in the Troubadour and McClellan
competitions. Her work has appeared in *Best Scottish Poems,
Poetry Review* and *Canadian Literature*. Her PhD thesis was
on the work of Tom Leonard at the University of Glasgow.
She is the online editor at the Scottish Review of Books and
a regular contributor to the Herald's book pages. She is the
author of the pamphlet *Close* (HappenStance Press, 2012).

Dilys Rose

Dilys Rose lives in Edinburgh. She is a novelist, short story
writer, poet and librettist and has published eleven books, most
recently *Pelmanism* (Luath, 2014), a novel. She is programme
director for the online MSc in Creative Writing at the
University of Edinburgh.

Acknowledgements

Thank you to Creative Scotland for financial support for
this project and many others. Acknowledgement and
appreciation to John Gifford, Colin McWilliam and David
Walker's *Edinburgh*, part of Penguin's seminal The Buildings
of Scotland series, first published in 1984. This proved to be
an invaluable resource in the making of this book. Thank you
to Anna Gurun for her research. Thank you also again to the
five poets, Jane Bonnyman, Ron Butlin, Anna Crowe,
Theresa Muñoz and Dilys Rose for their outstanding
responses to the imagery included here. Final thanks to
Robbie Guillory, Andrew Forteath and Adam Turner, for
steering this book through its production journey.